MANDALA MYTHICAL
ADULT COLORING BOOK

SCALES & CLAWS
BOOK 2

PRODUCED BY

Maya Necalli

&

Art Therapy Designs

Copyright © 2016 by Maya Necalli
All rights reserved.

Images may not be replicated or reproduced.

No part of this publication may be reproduced, transmitted or circulated in any form without permission in writing from the copyright owner.

ISBN: 153955838X
ISBN-13: 978-1539558385

Cover design by Art Therapy Designs.

First Edition: October 2016

INTRODUCTION

Art Therapy Designs presents unique theme-based mandala collections inspired by various cultures and the natural world, including fantastical creatures. This is the second book in the *Mandala Mythical: Scales & Claws* series.

This coloring book contains **45** scaly patterns inspired by dragons and presented as single-sided pages to help preserve each illustration.

The designs range from fairly easy to high difficulty, with most of the designs on the challenging side.

Feel free to begin wherever you'd like!

Coloring is a form of art therapy, a creative calming technique that aids in de-stressing and relaxation.

Our therapeutic activity book is designed for grownups but suitable for all advanced children and teens.

Enjoy!

NOTE: Cover image can be found near the end.

SPECIAL OFFERS

Visit our Facebook page to get free designs and find out when new coloring books are available!

Go to: www.facebook.com/ArtTherapyDesigns

You can also win freebies and keep up with new releases by joining our newsletter (see Facebook page).

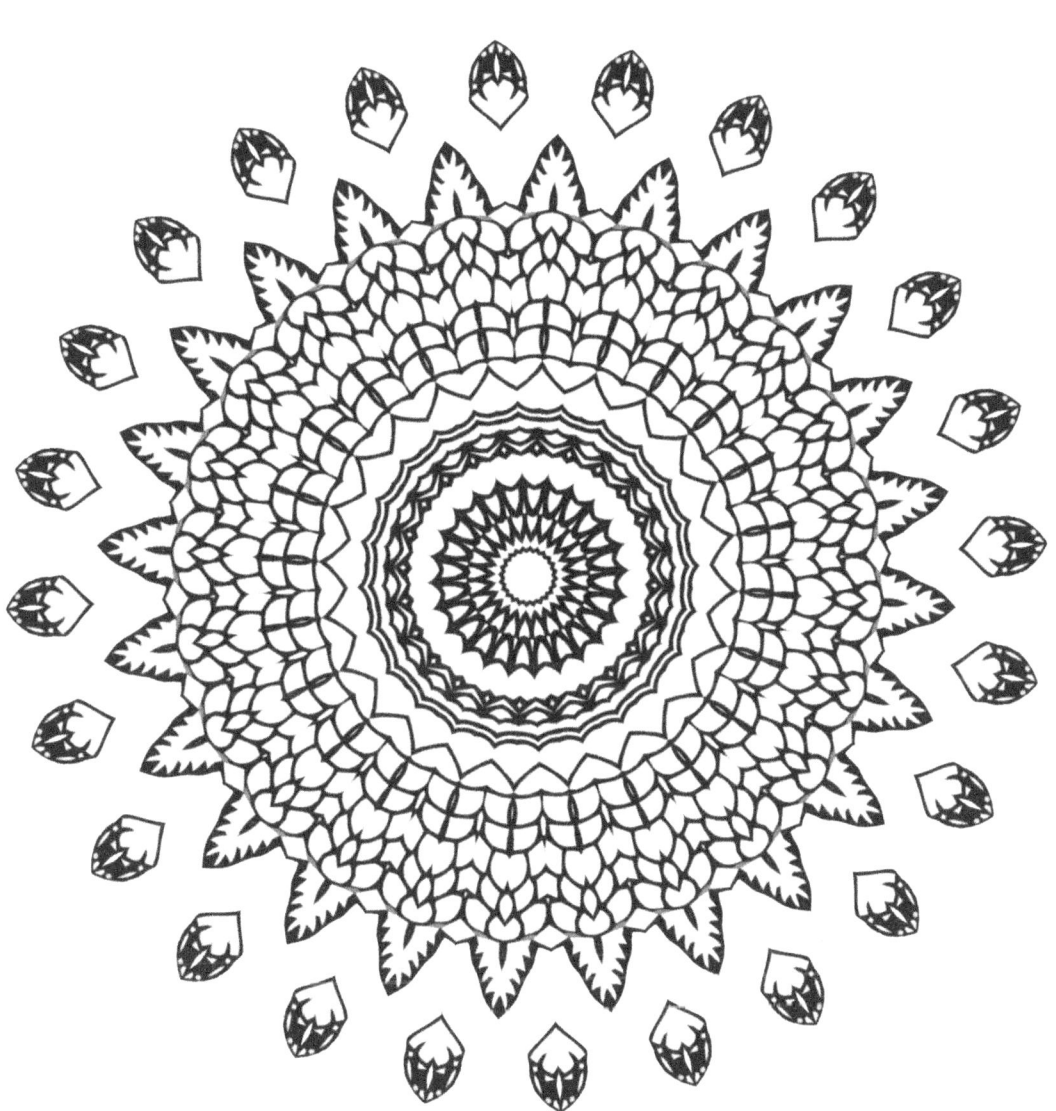

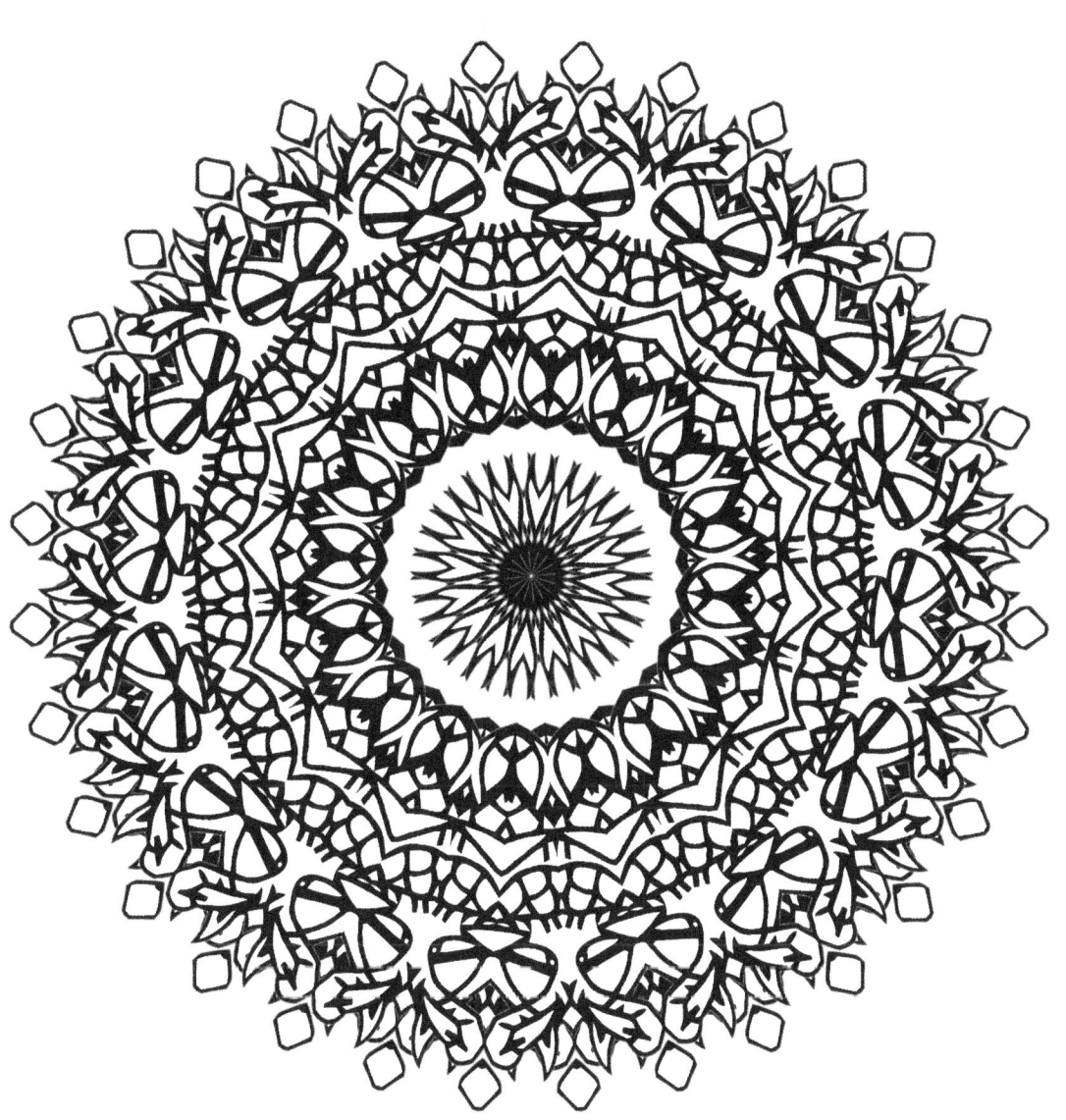

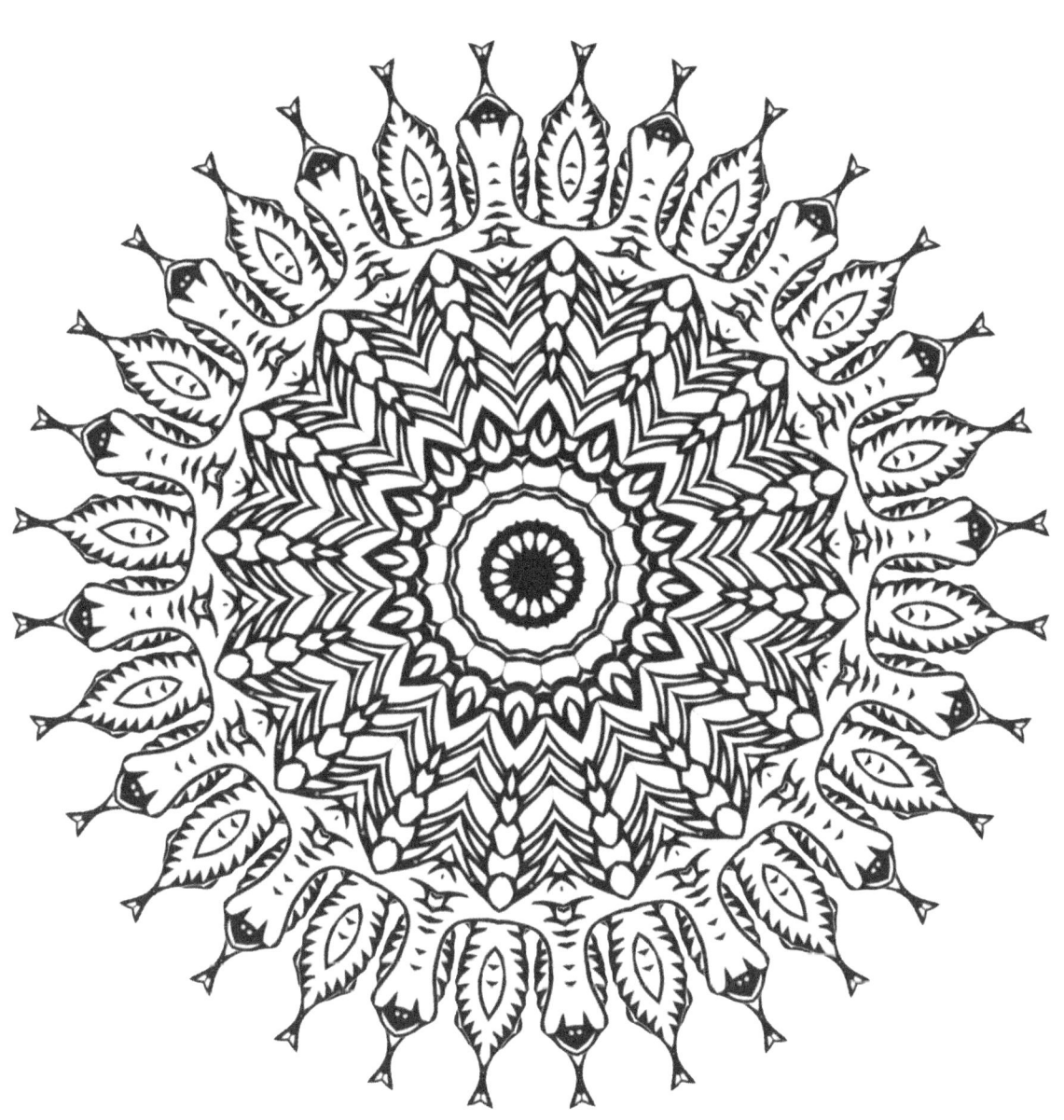

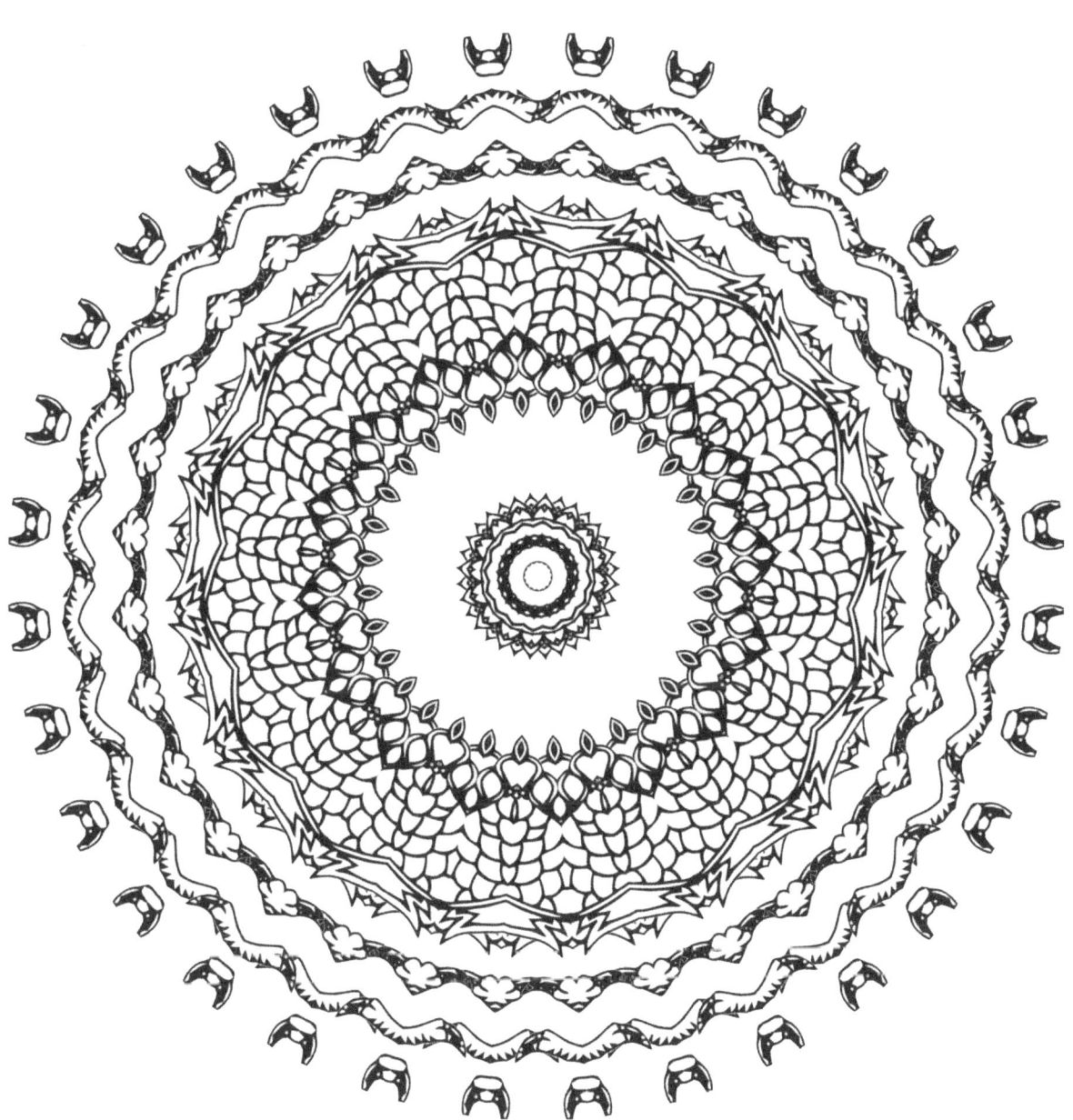

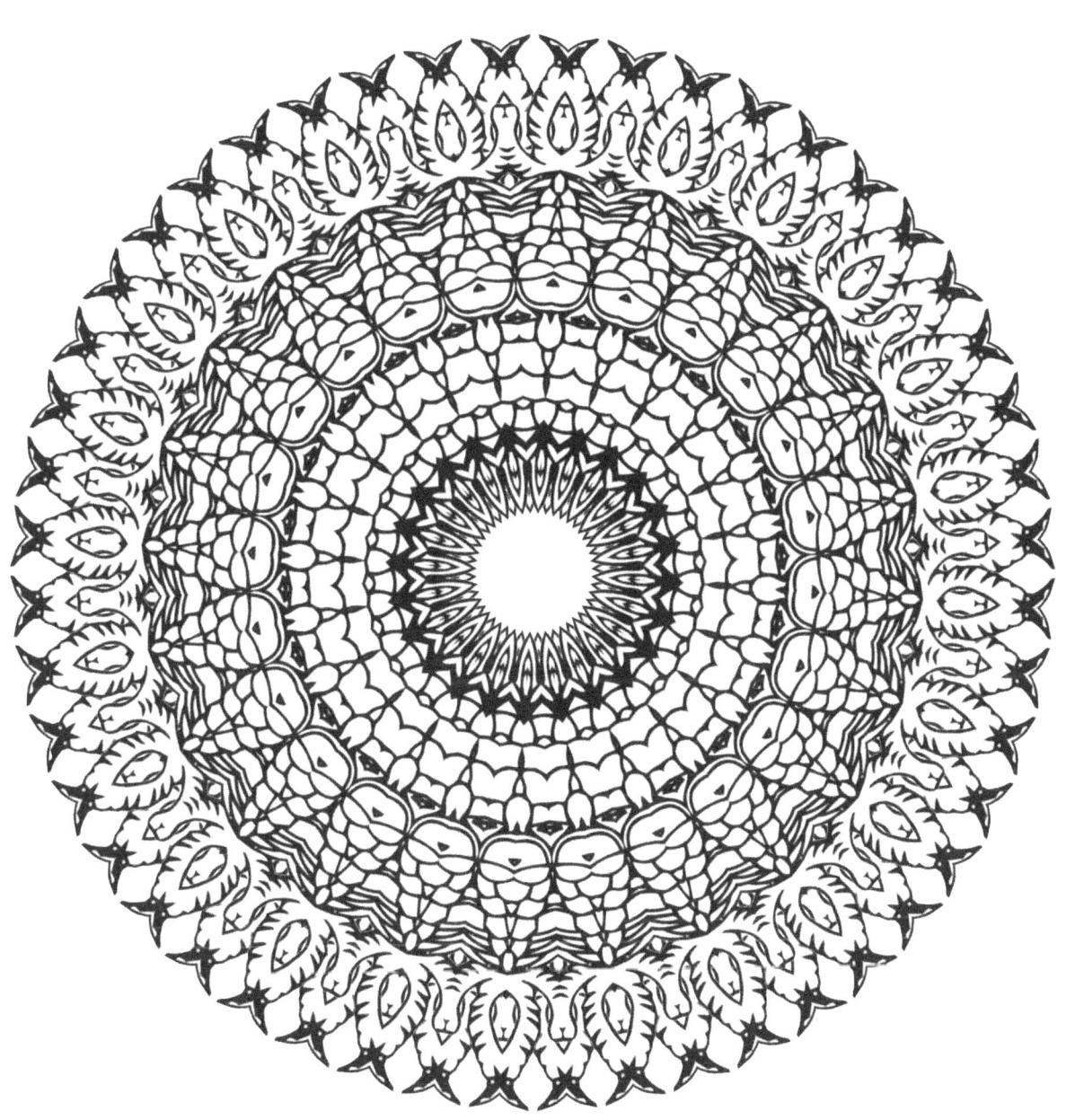

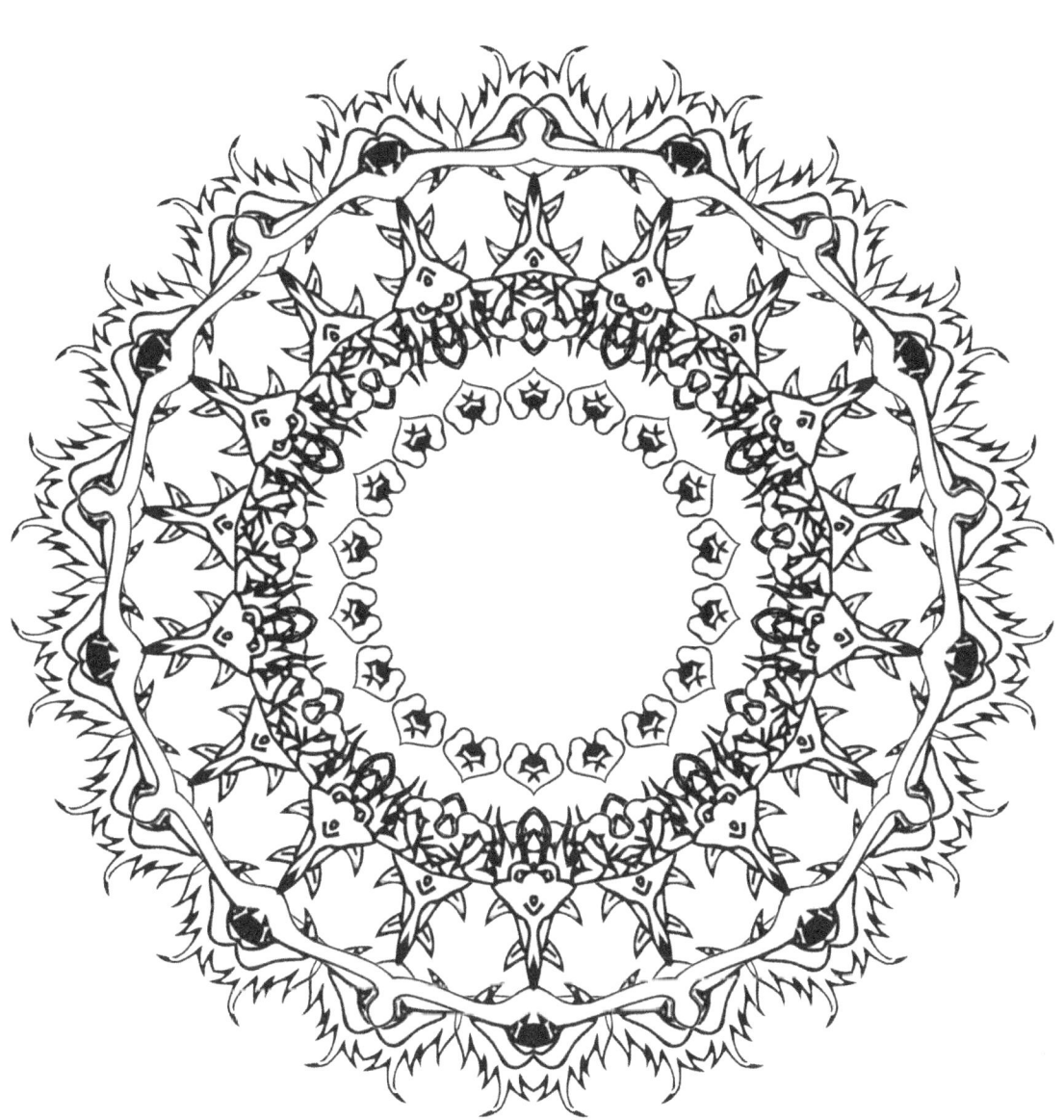

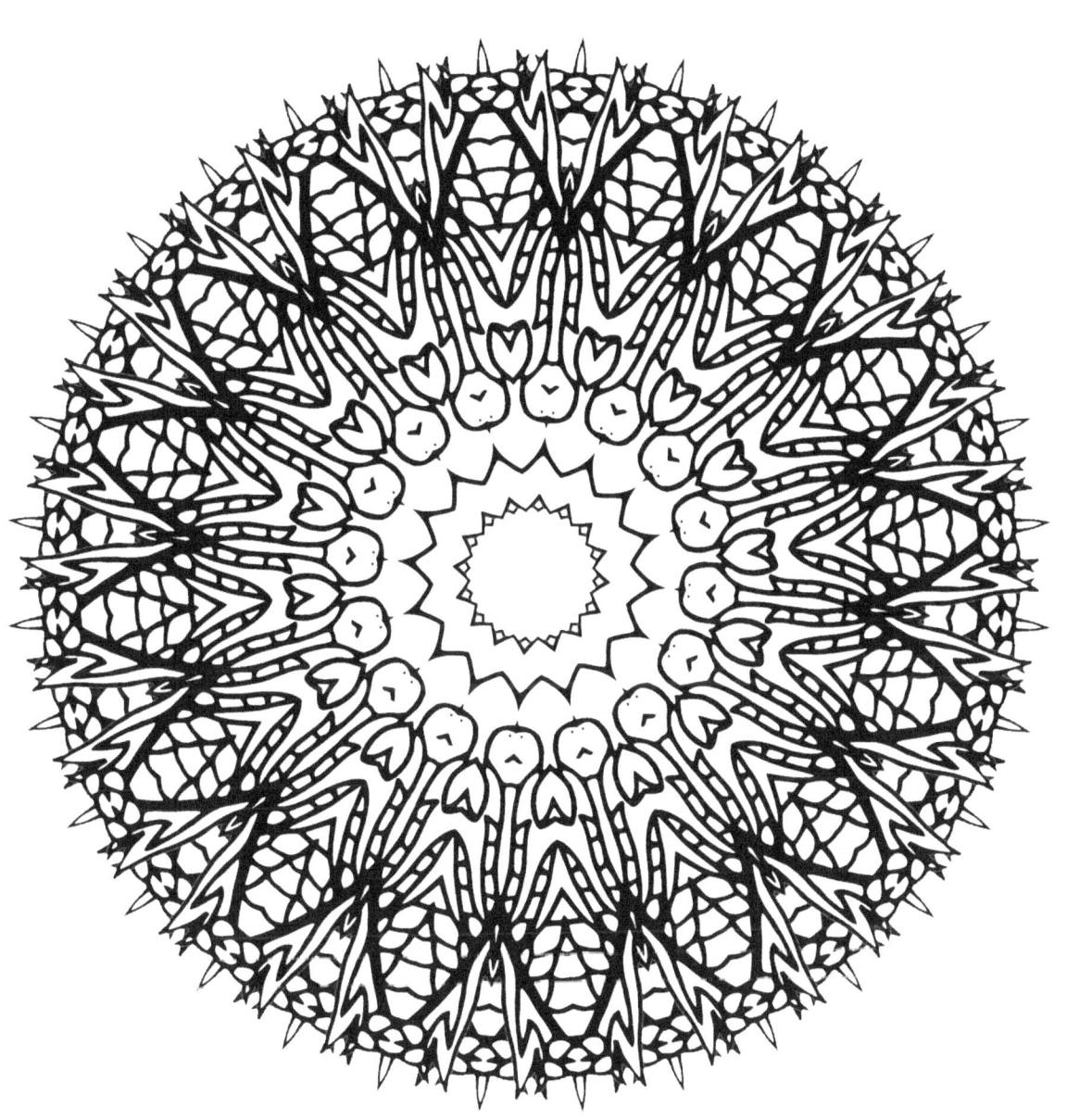

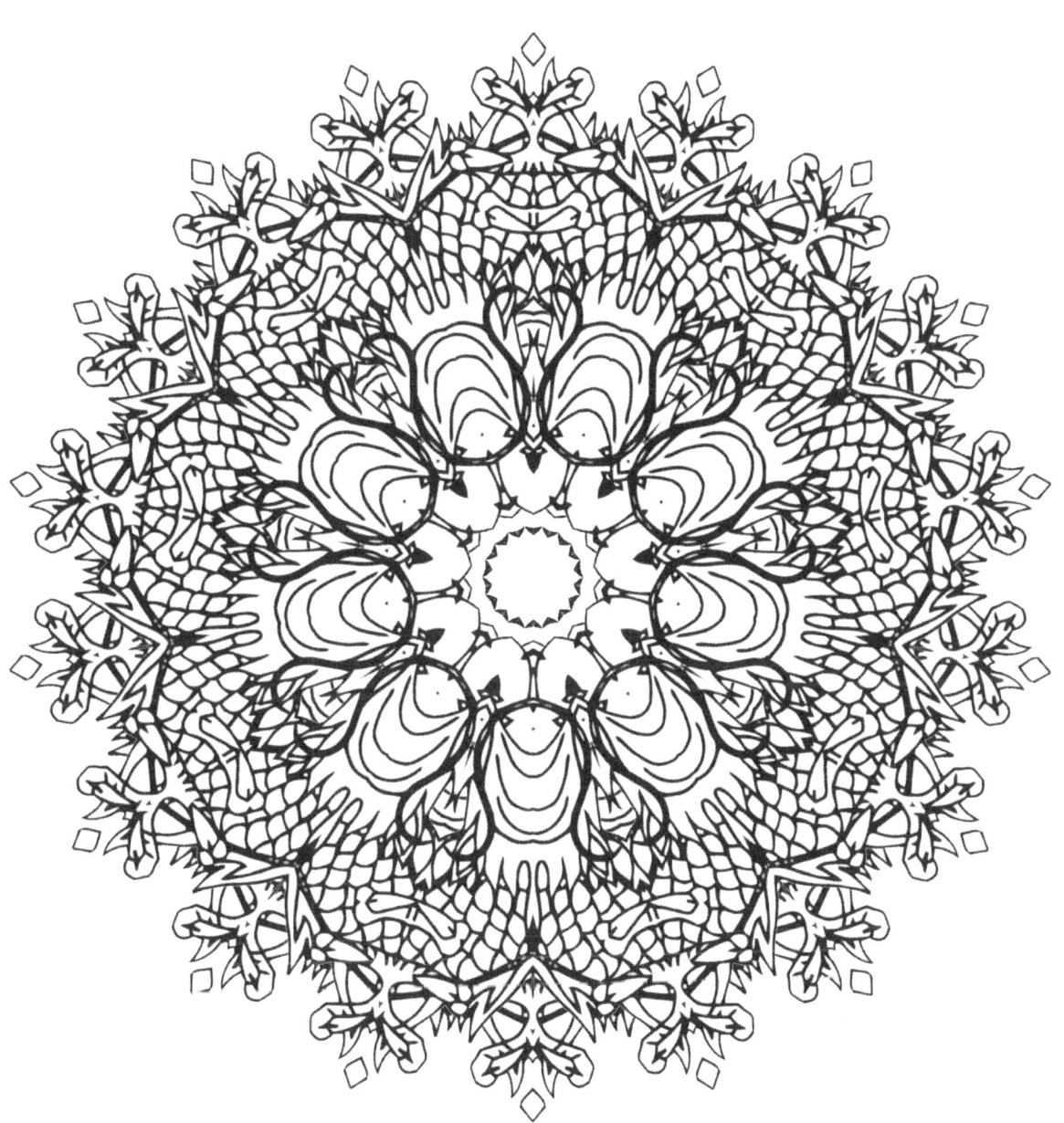

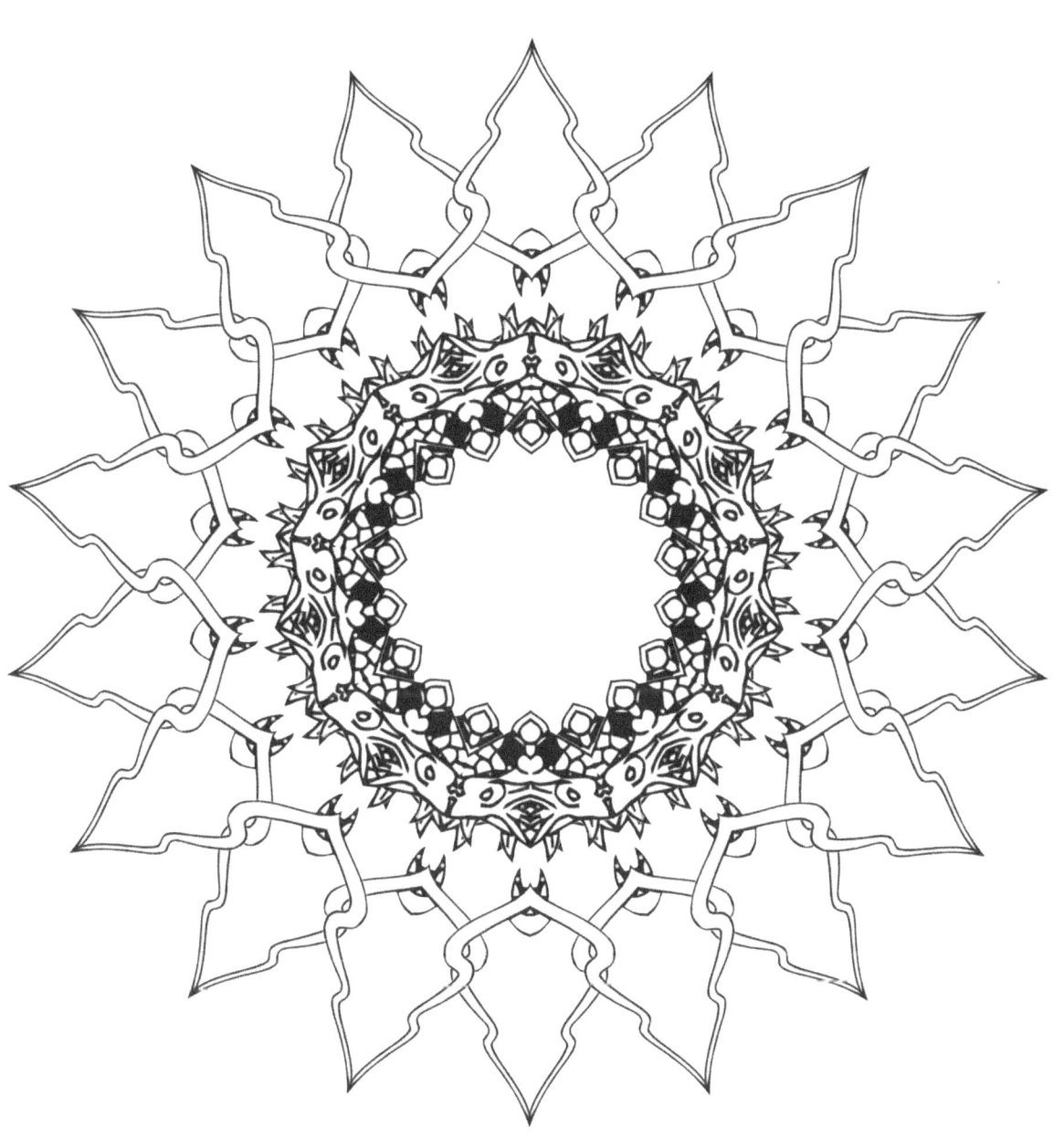

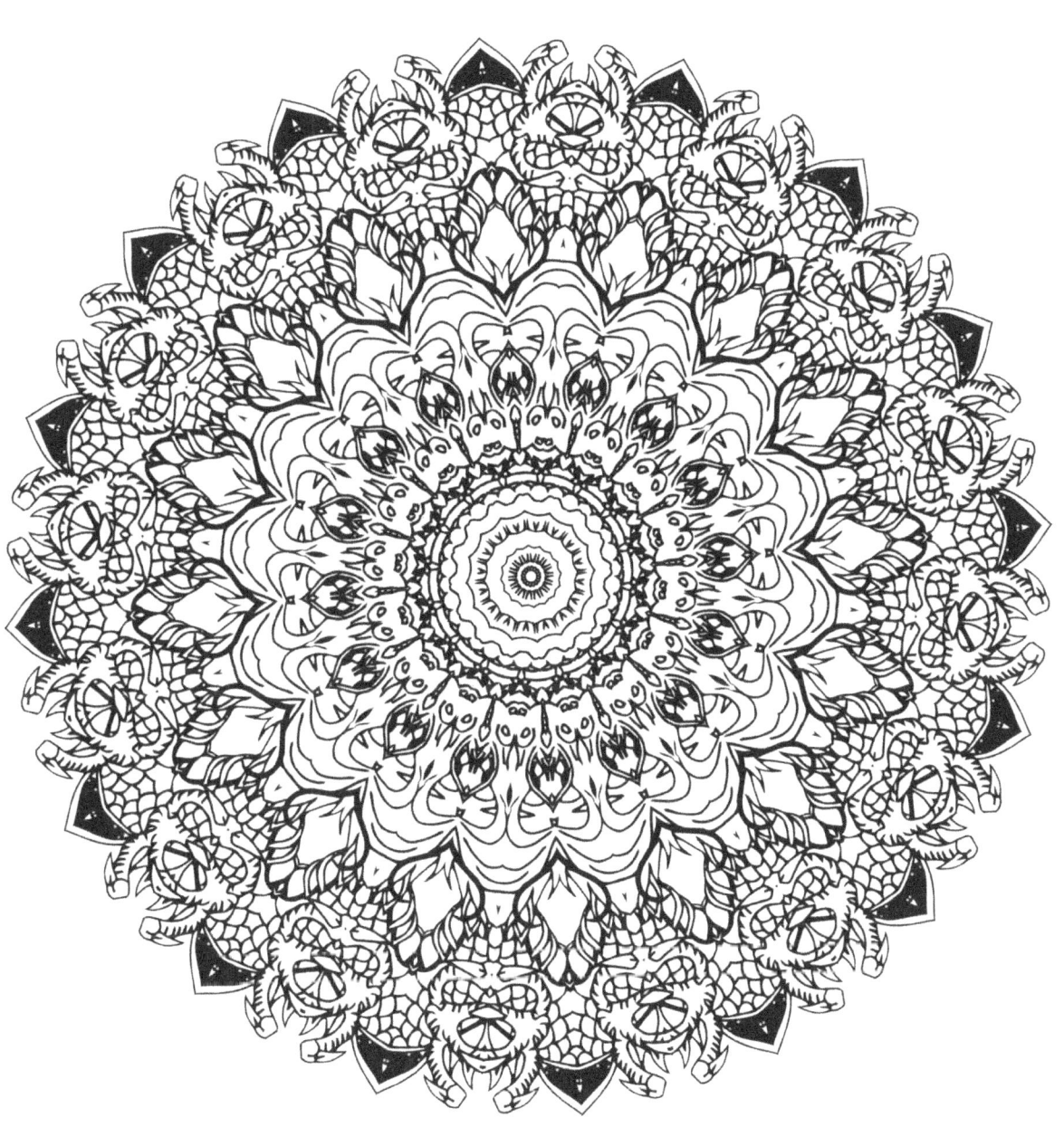

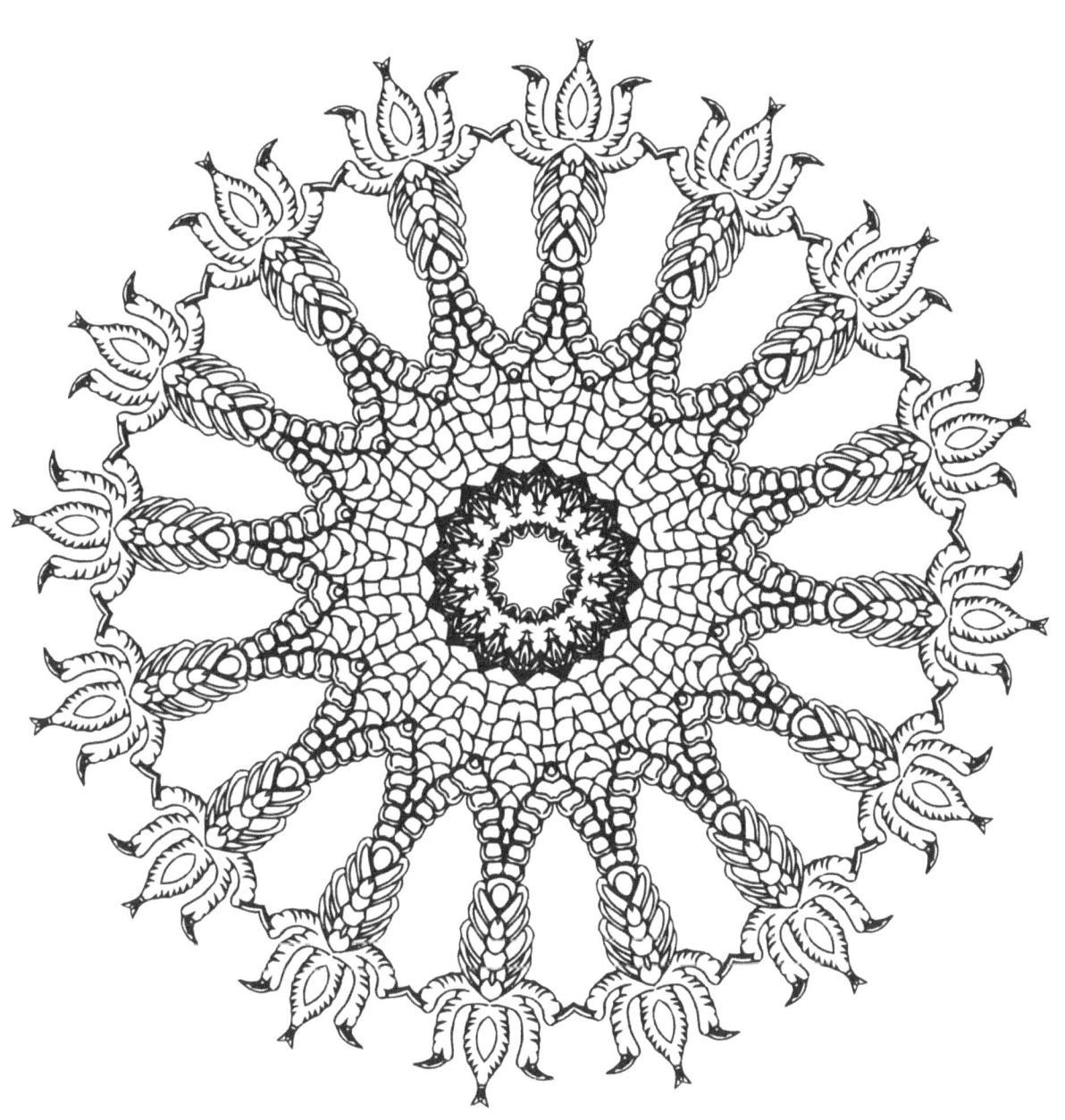

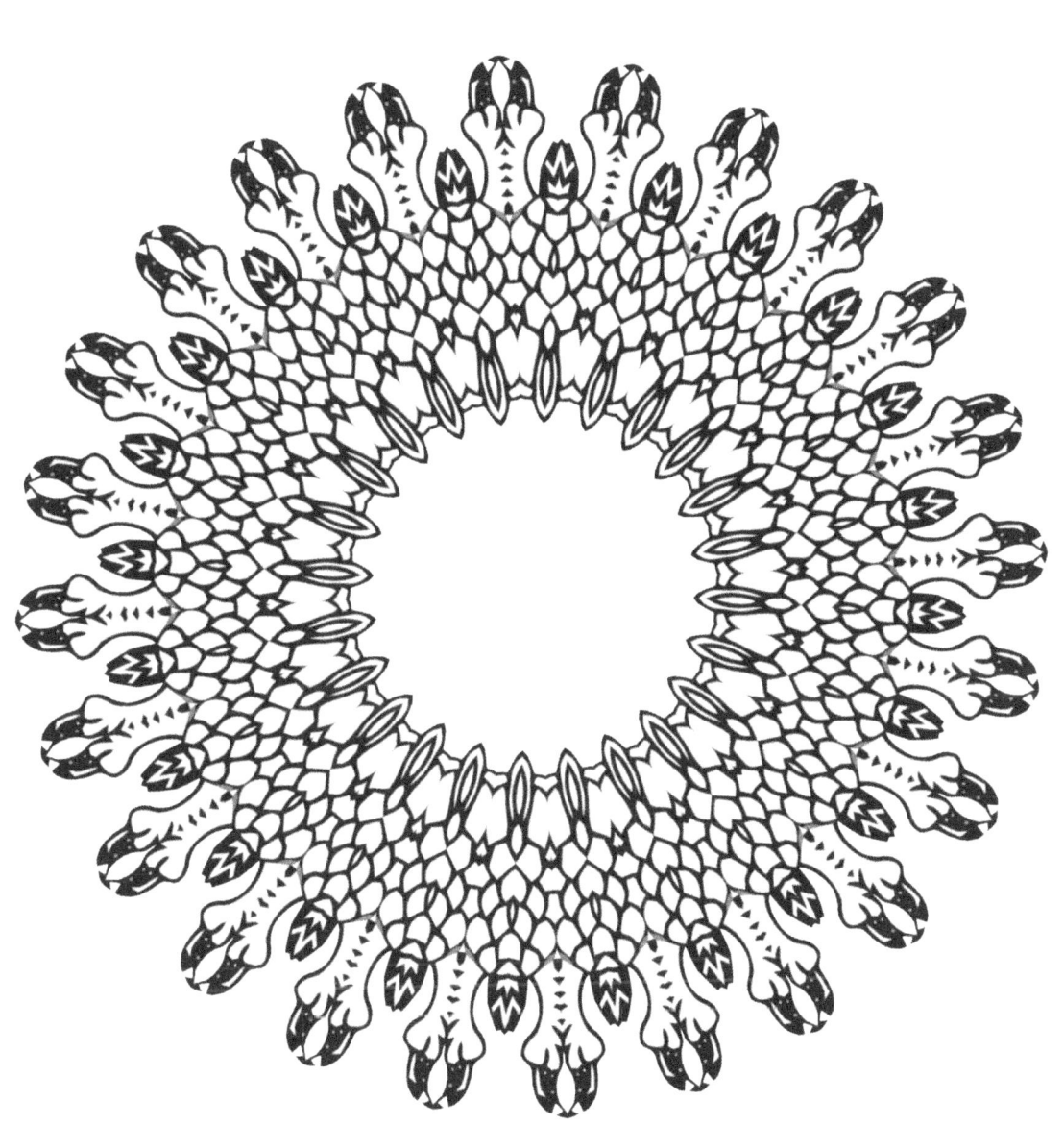

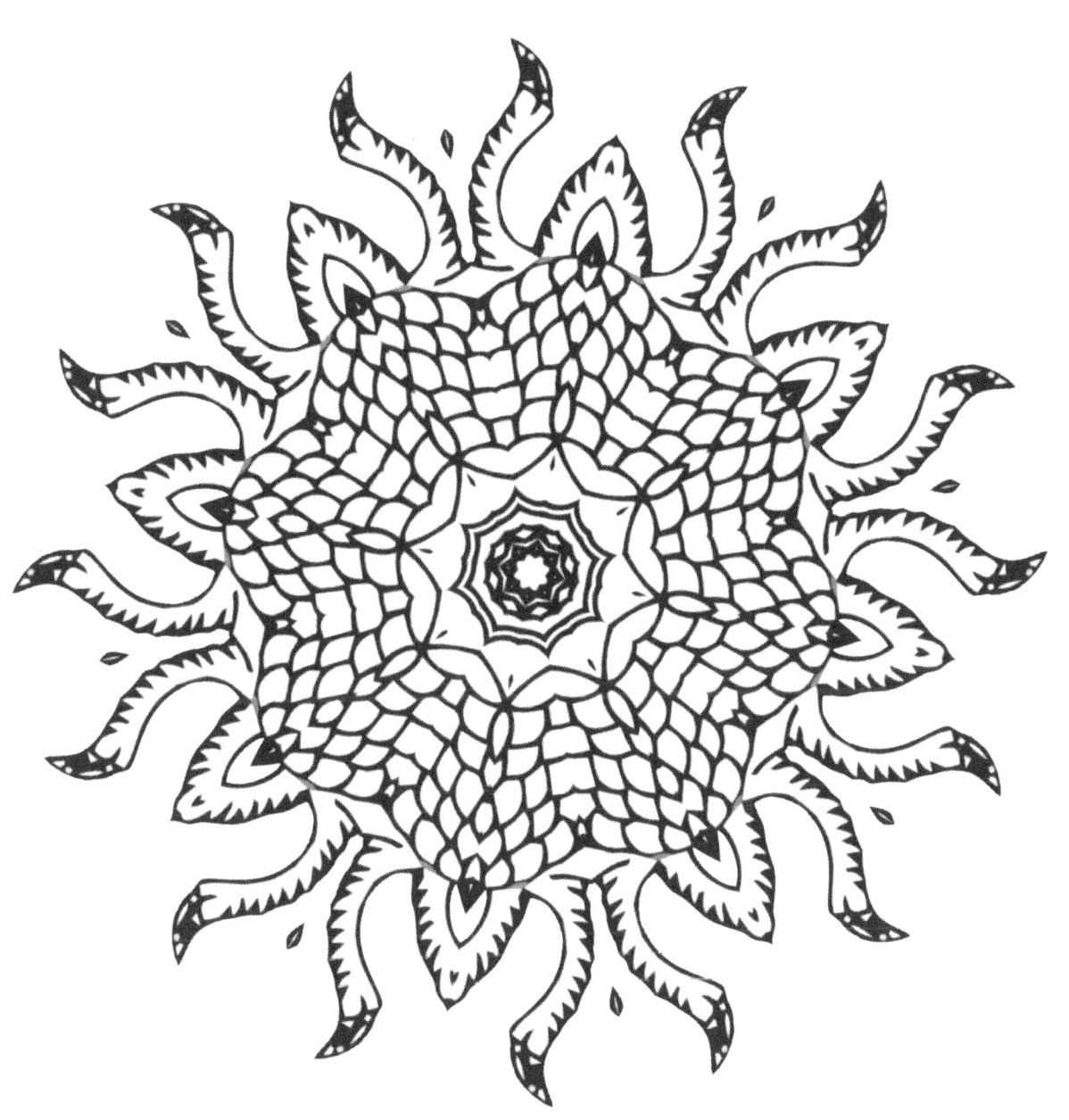

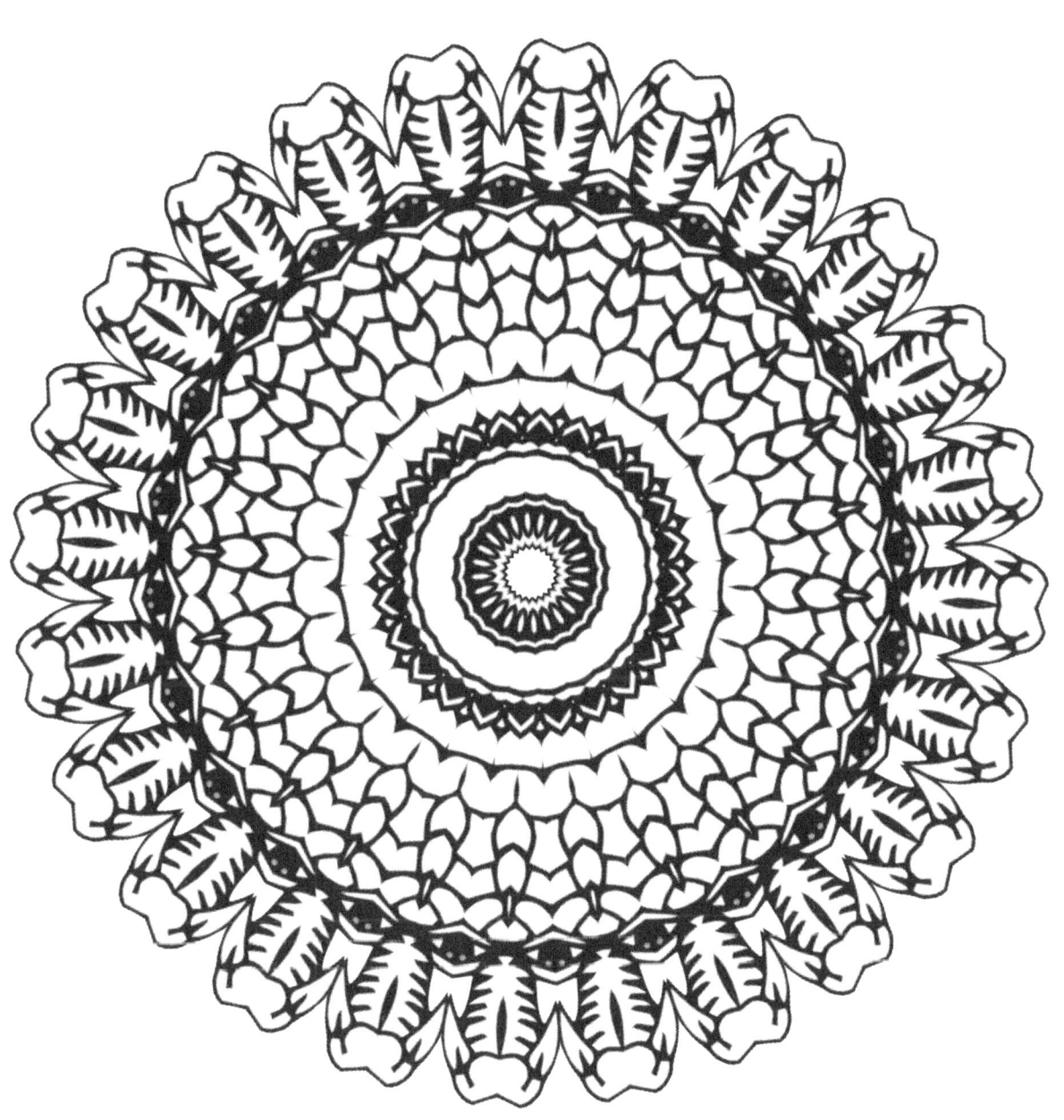

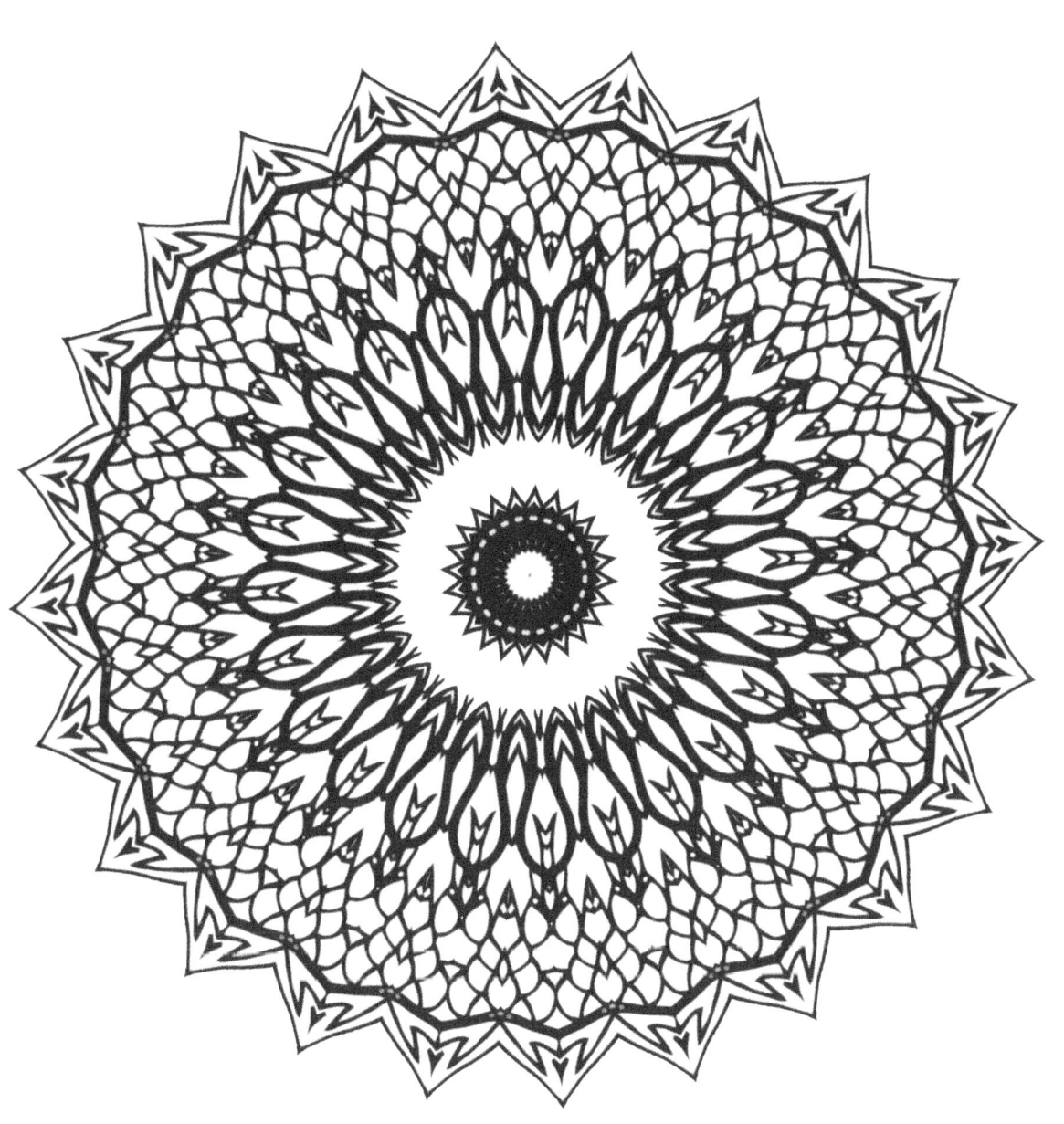

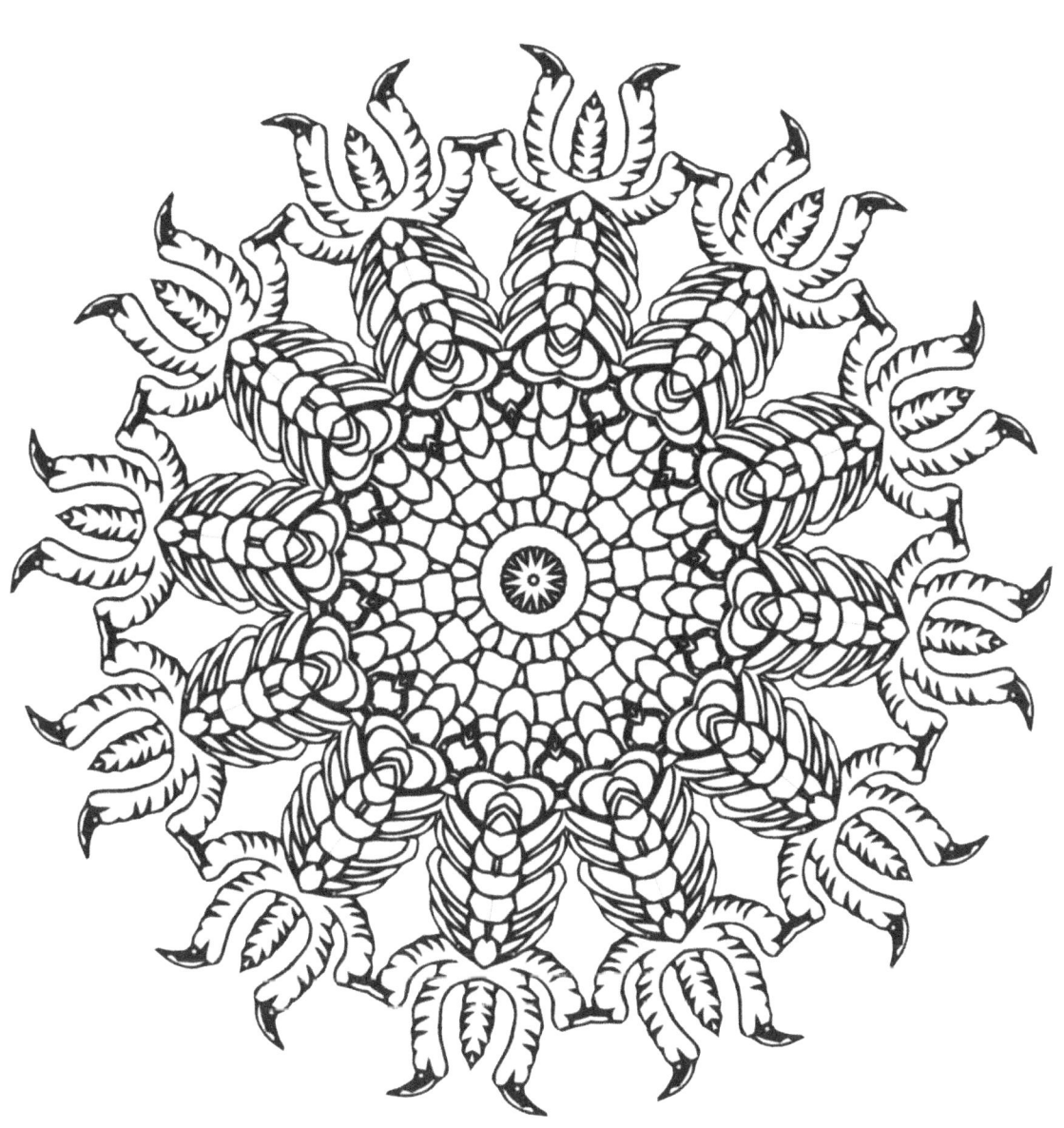

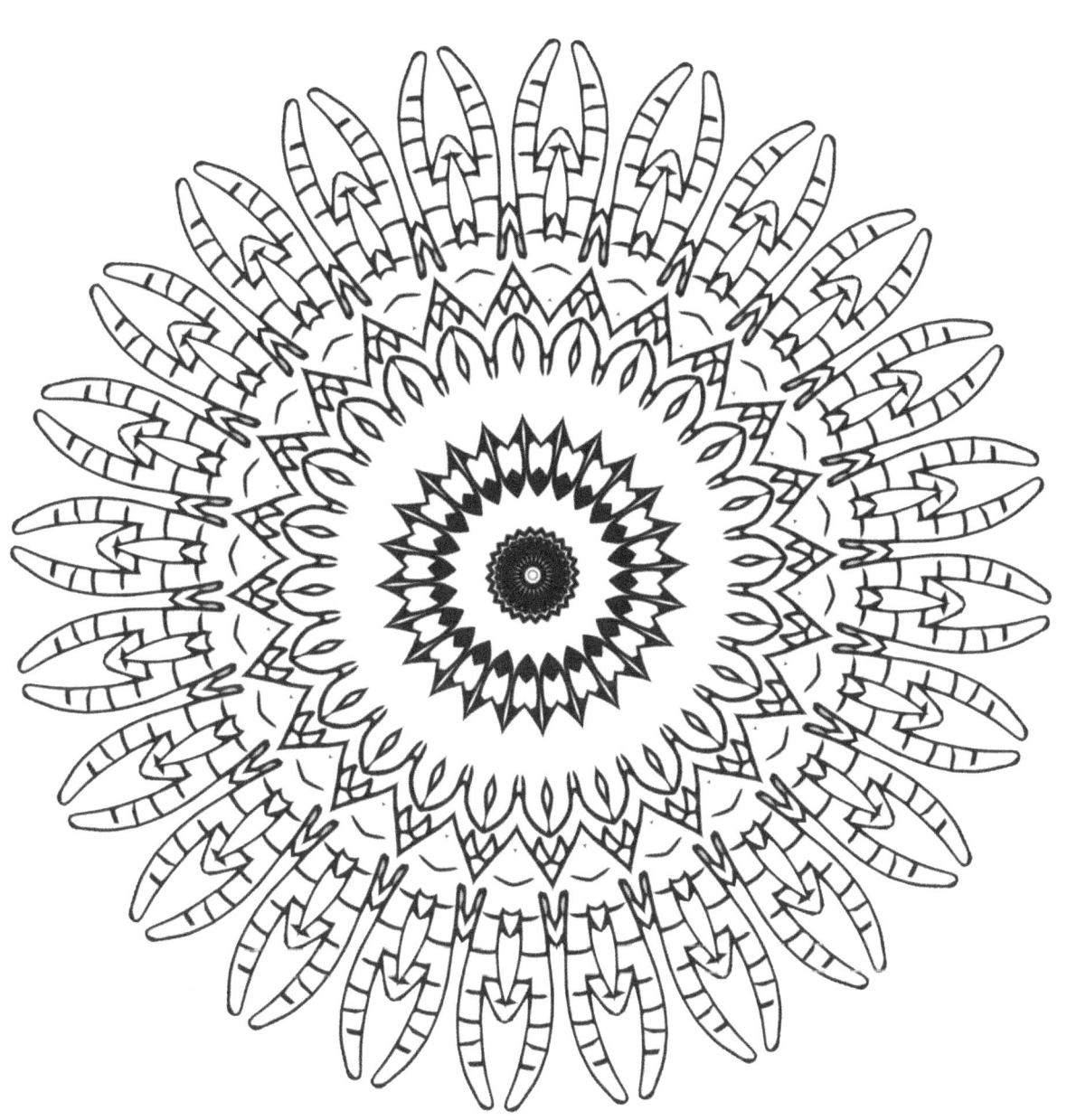

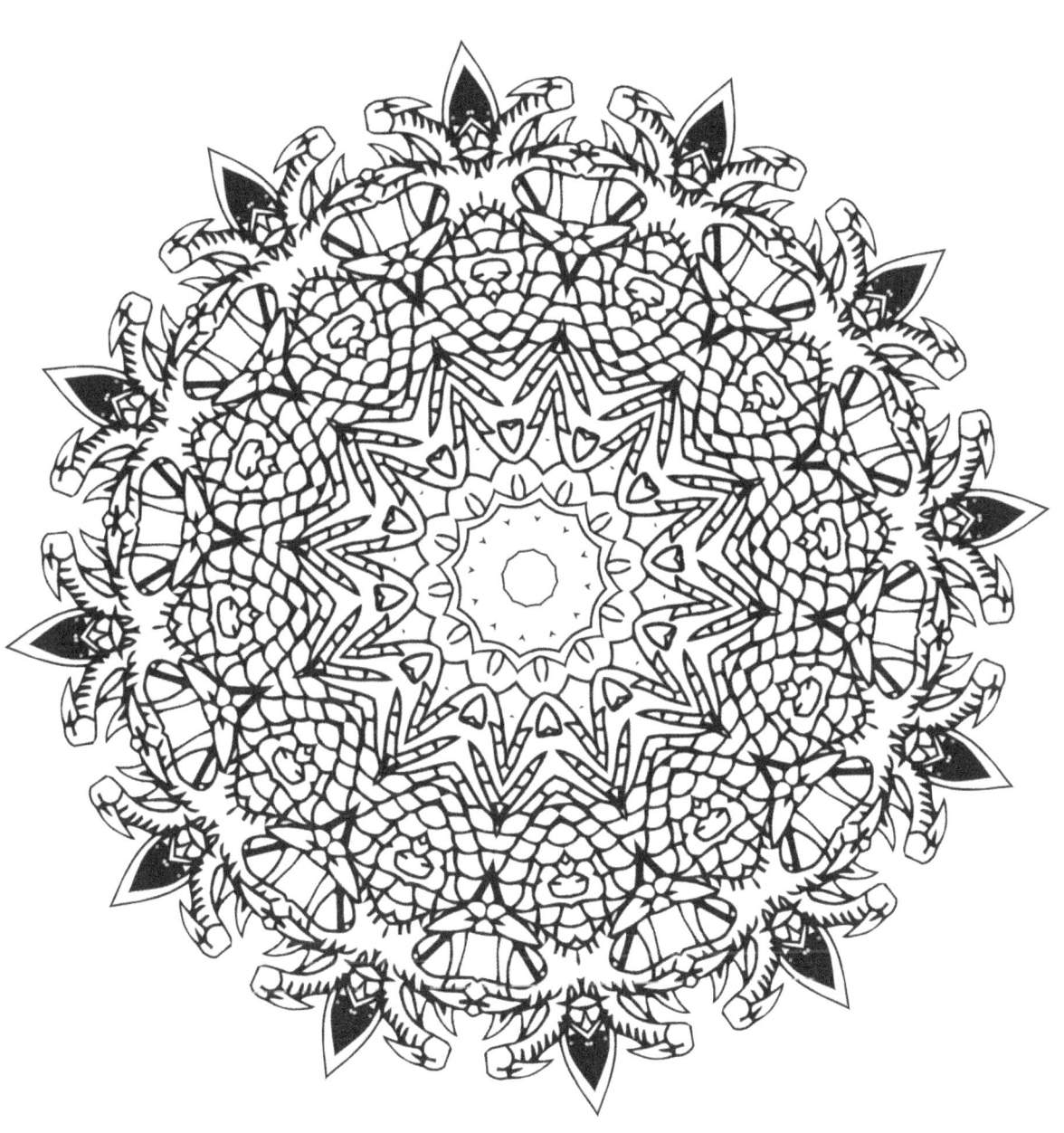

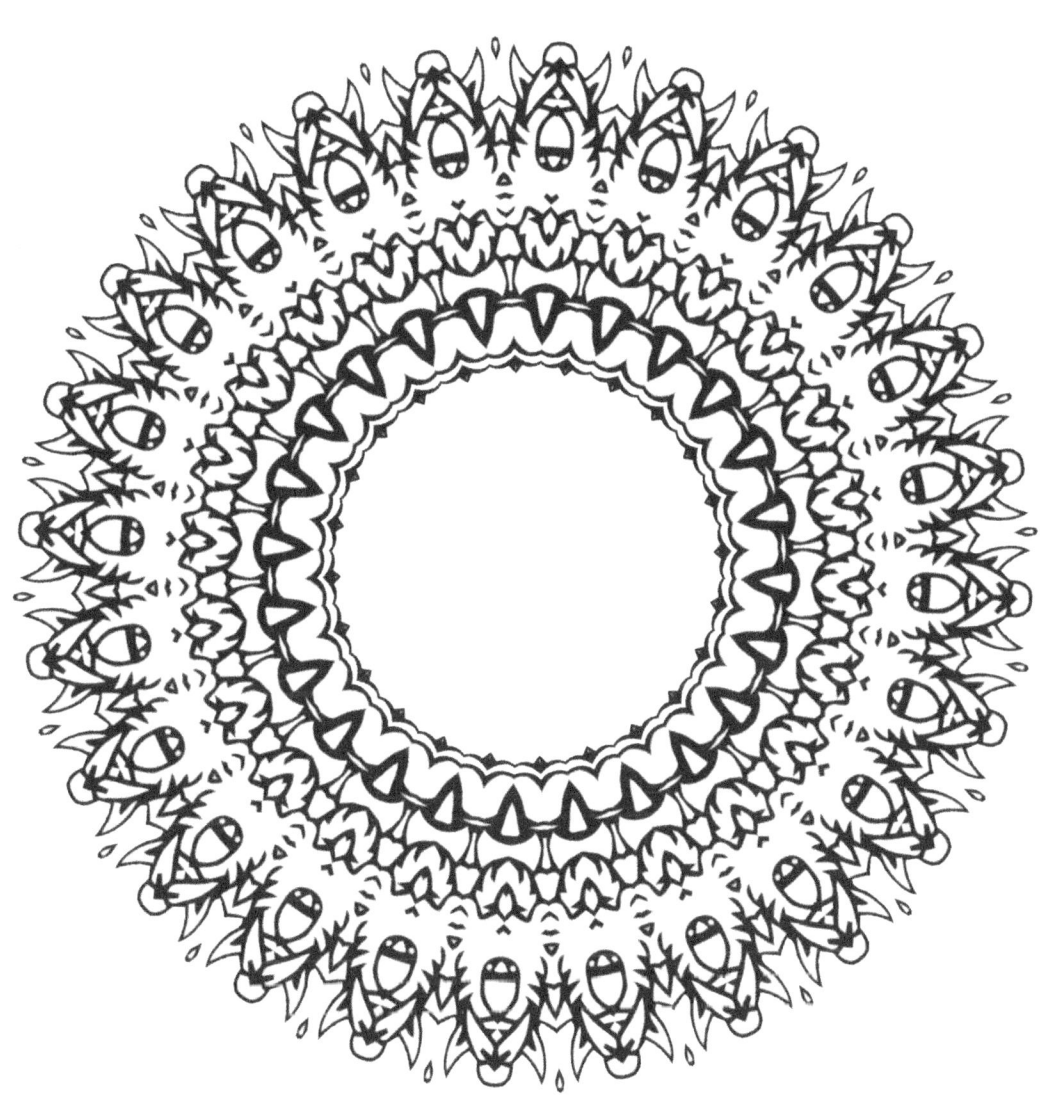

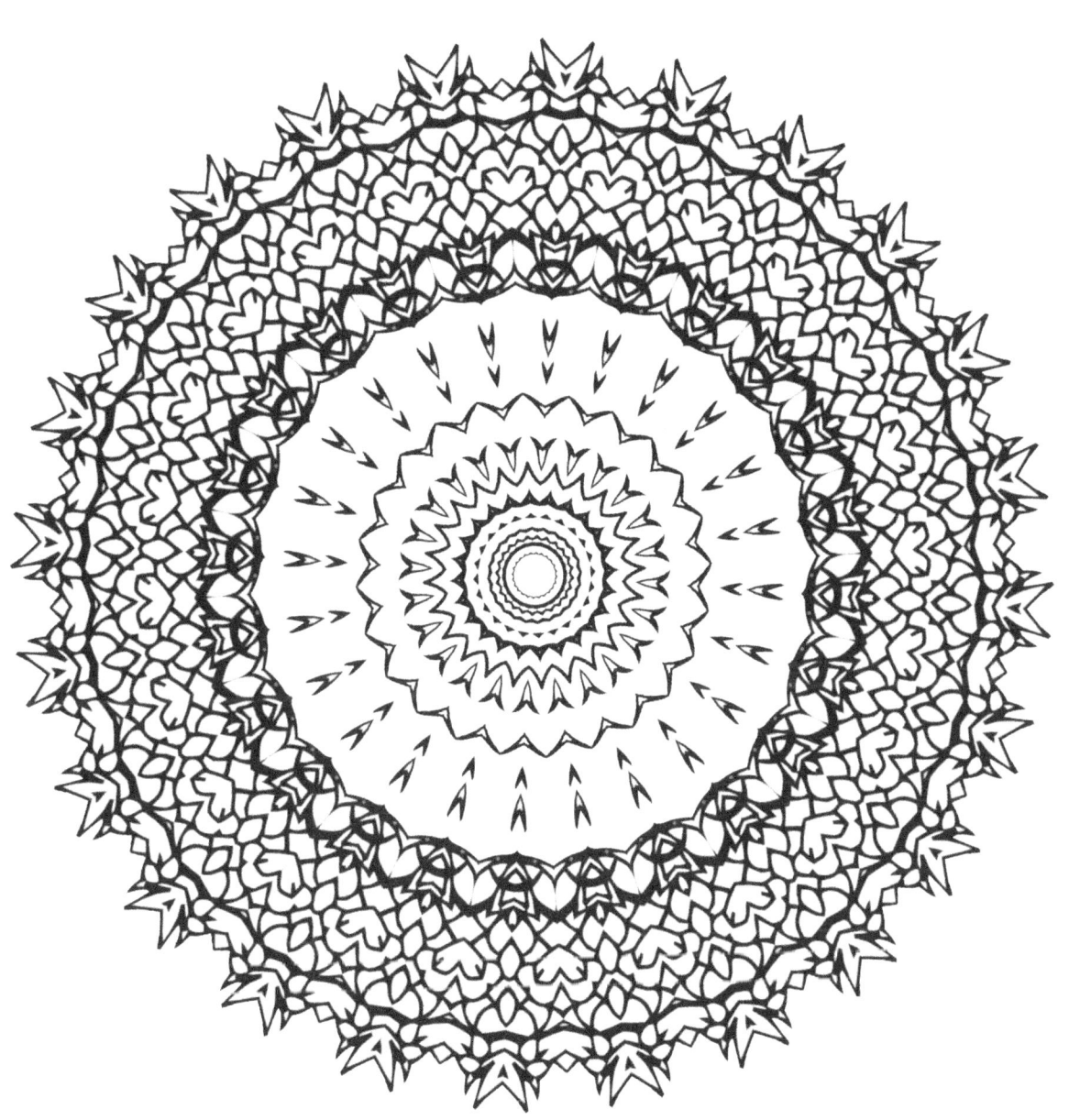

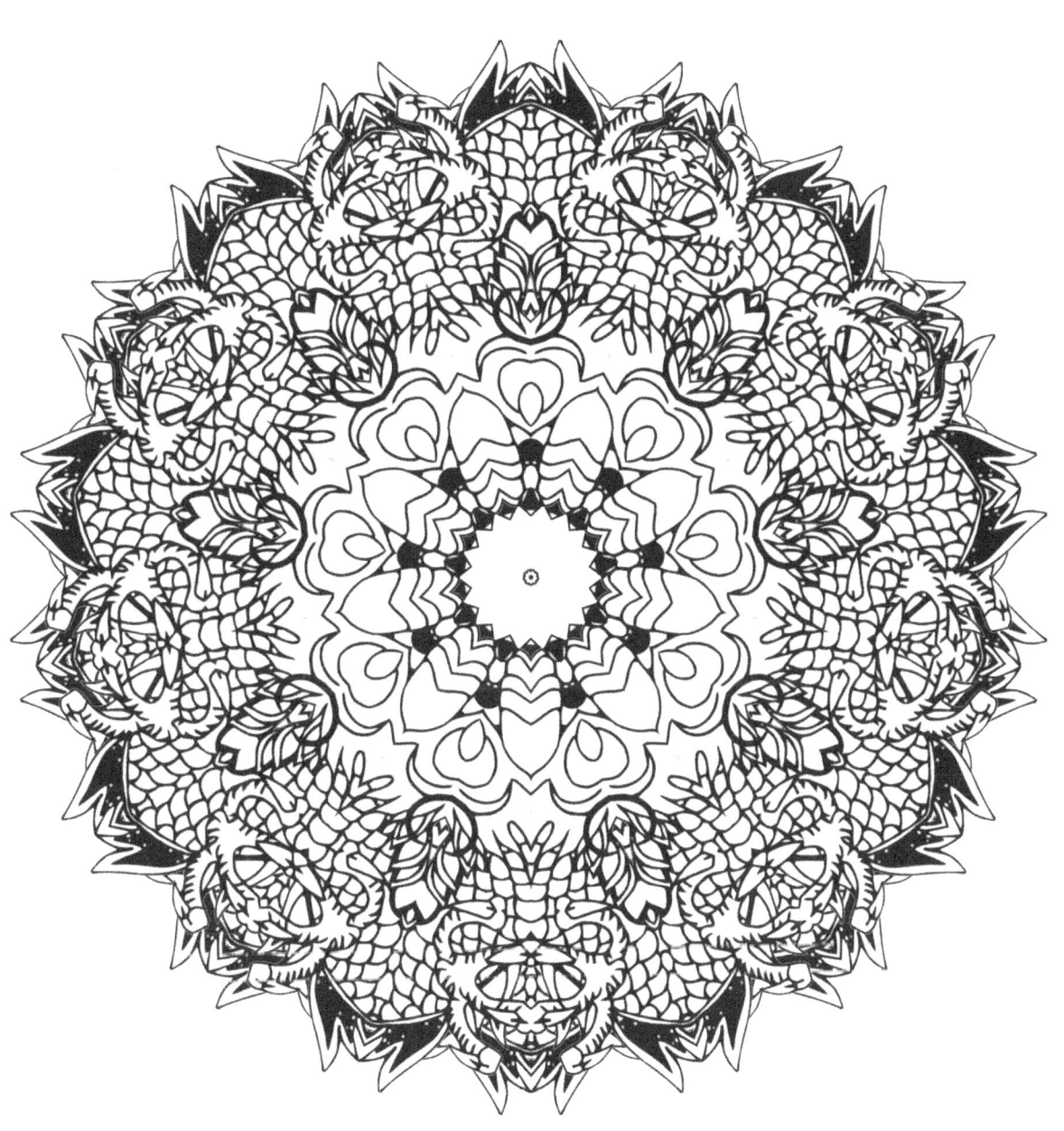

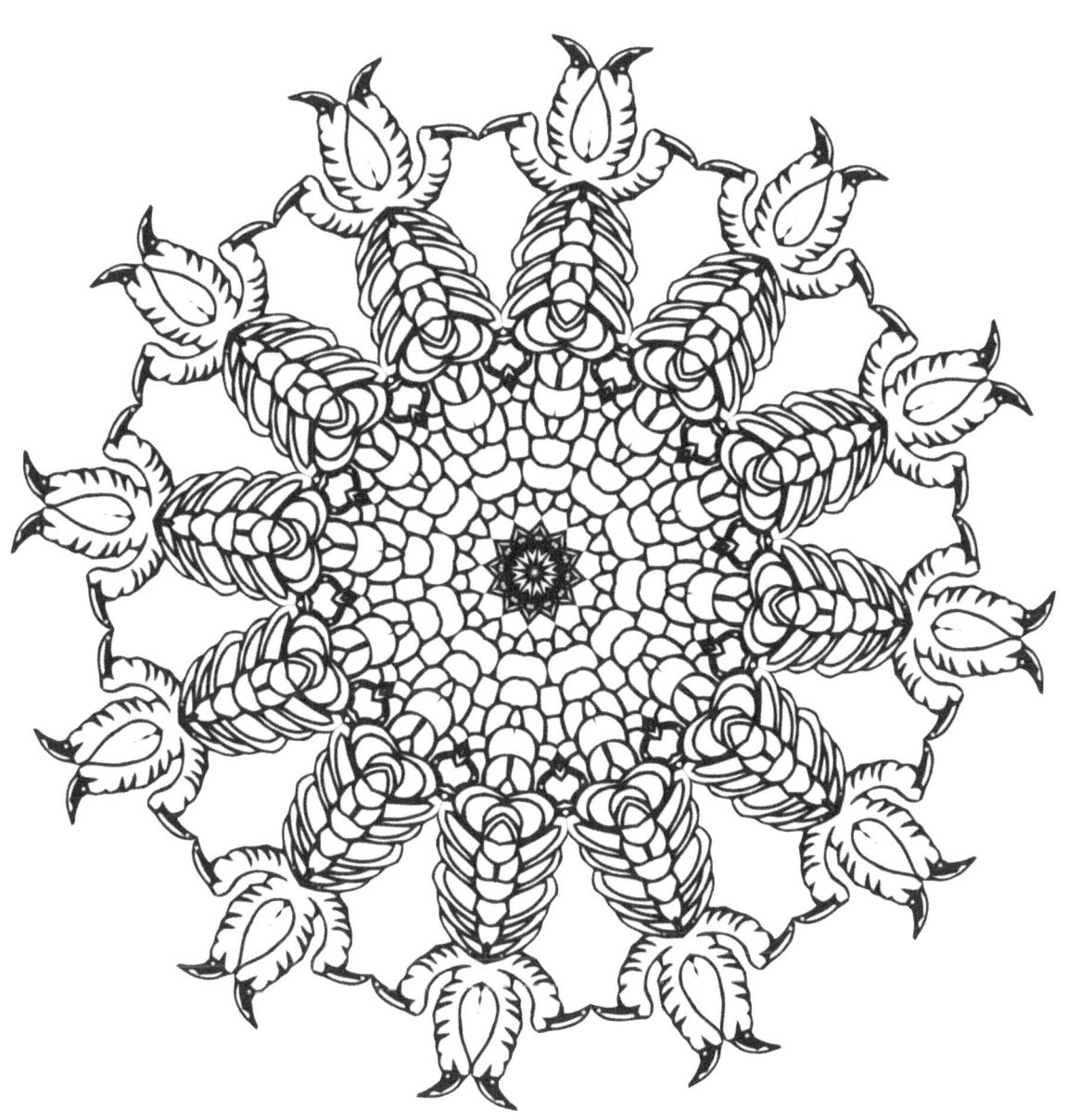

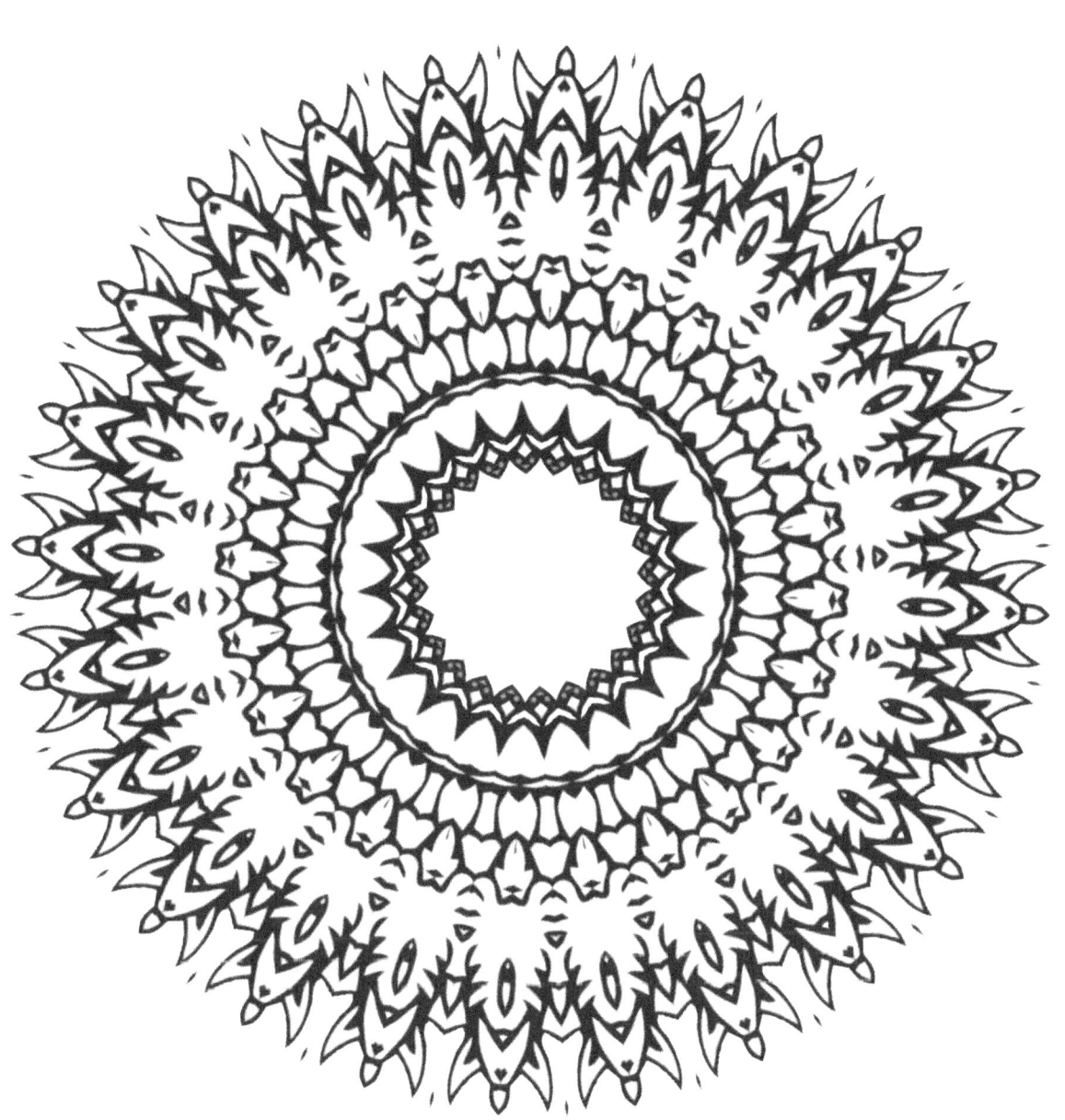

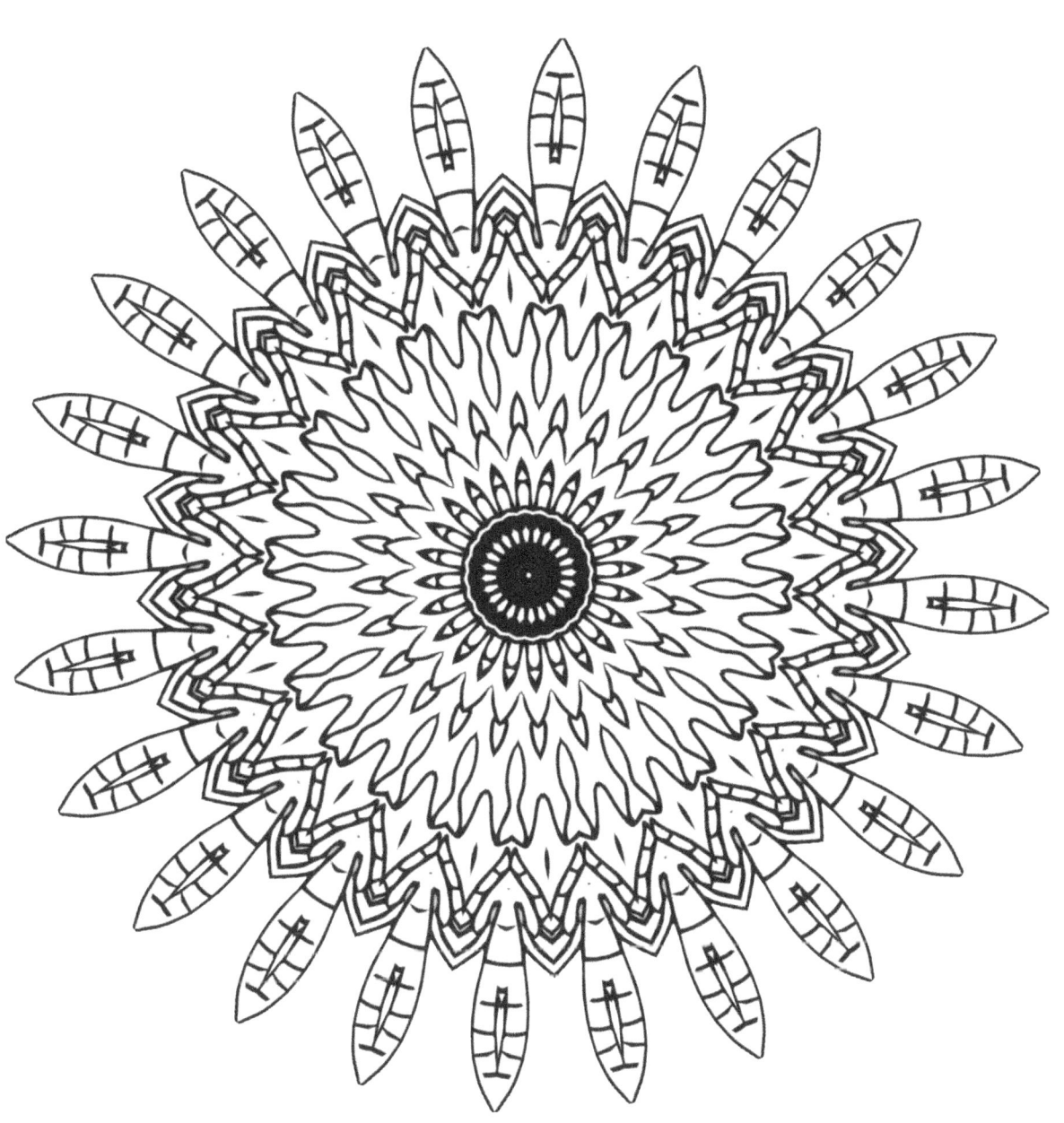

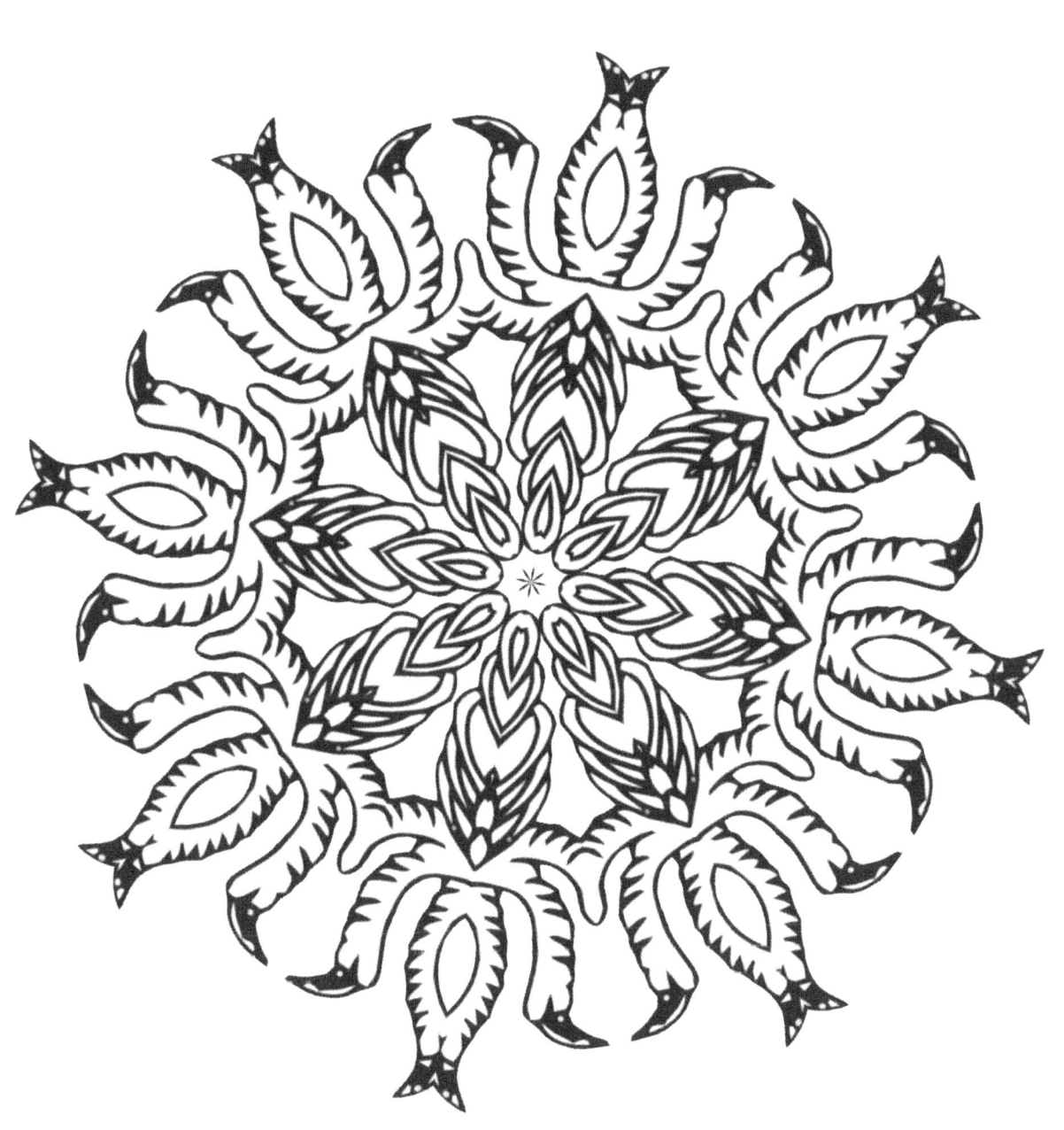

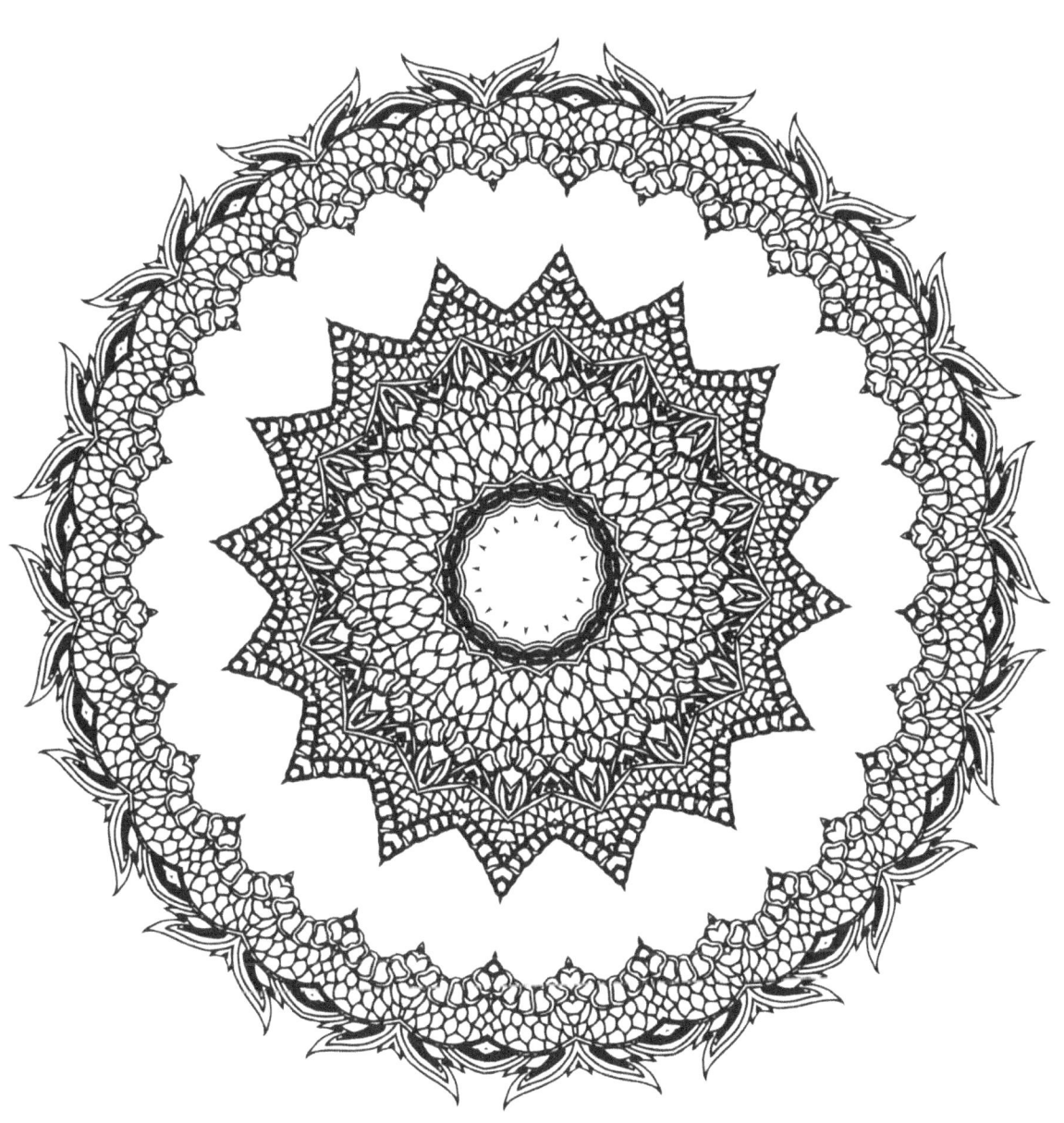

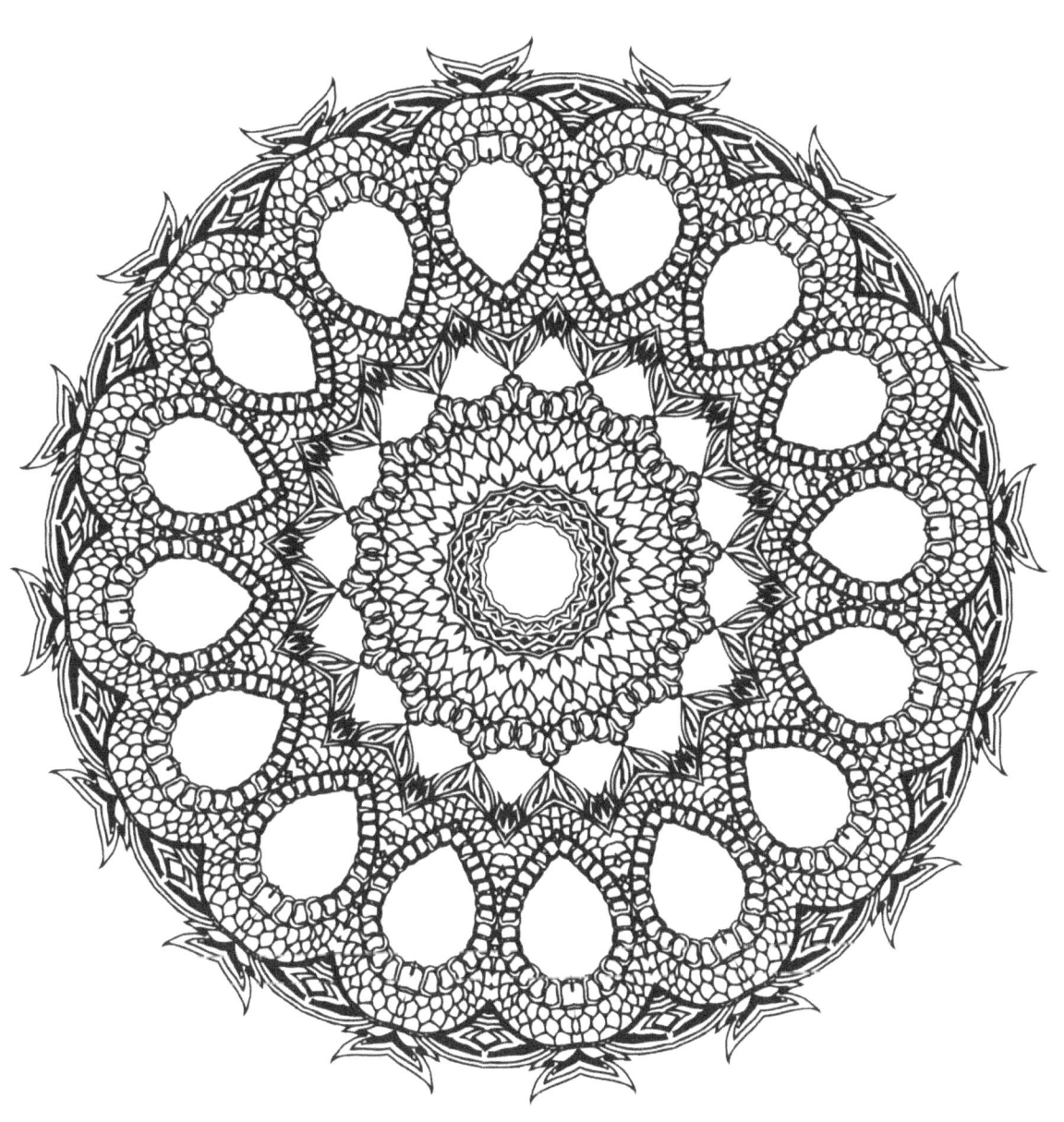

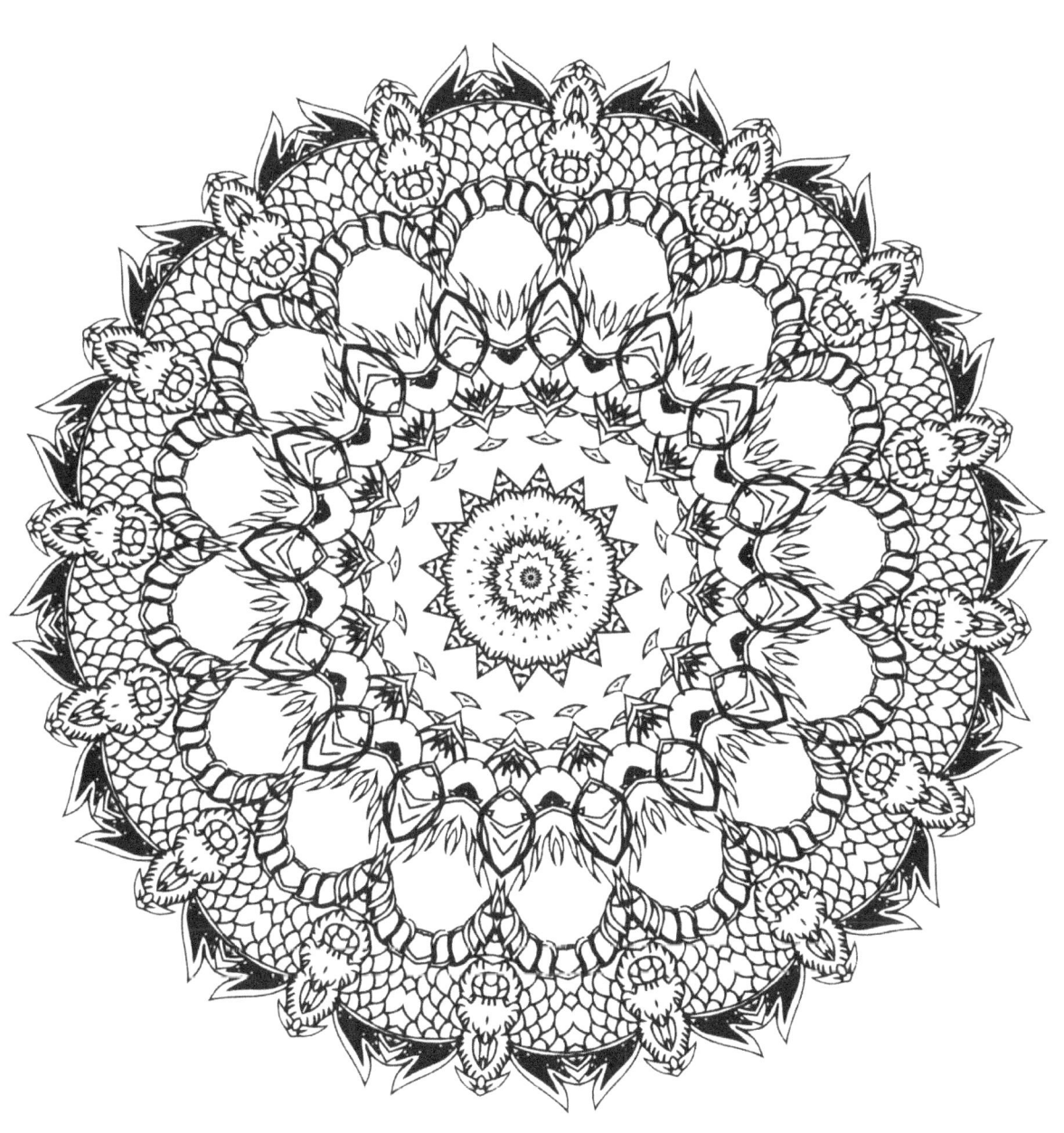

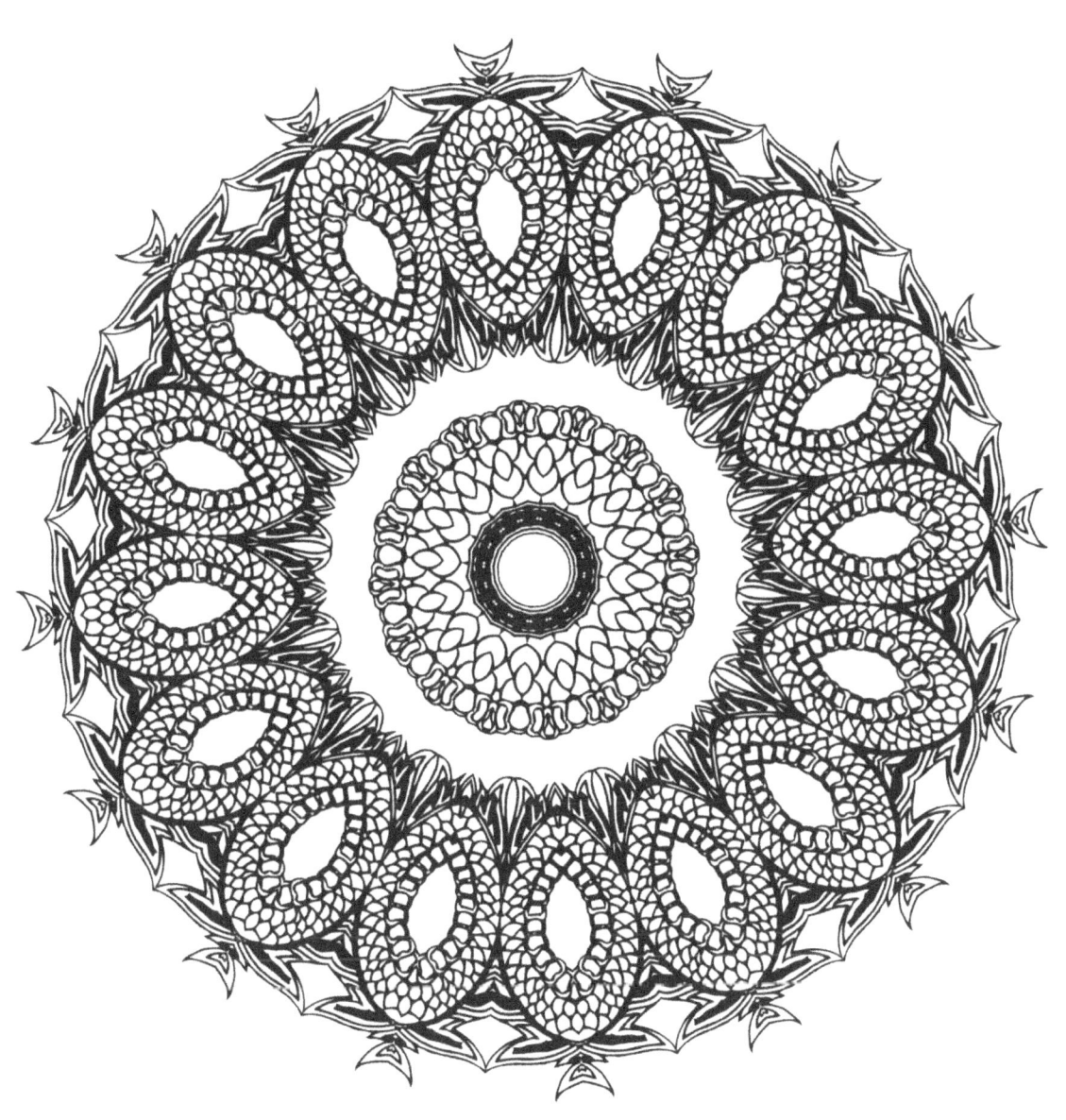

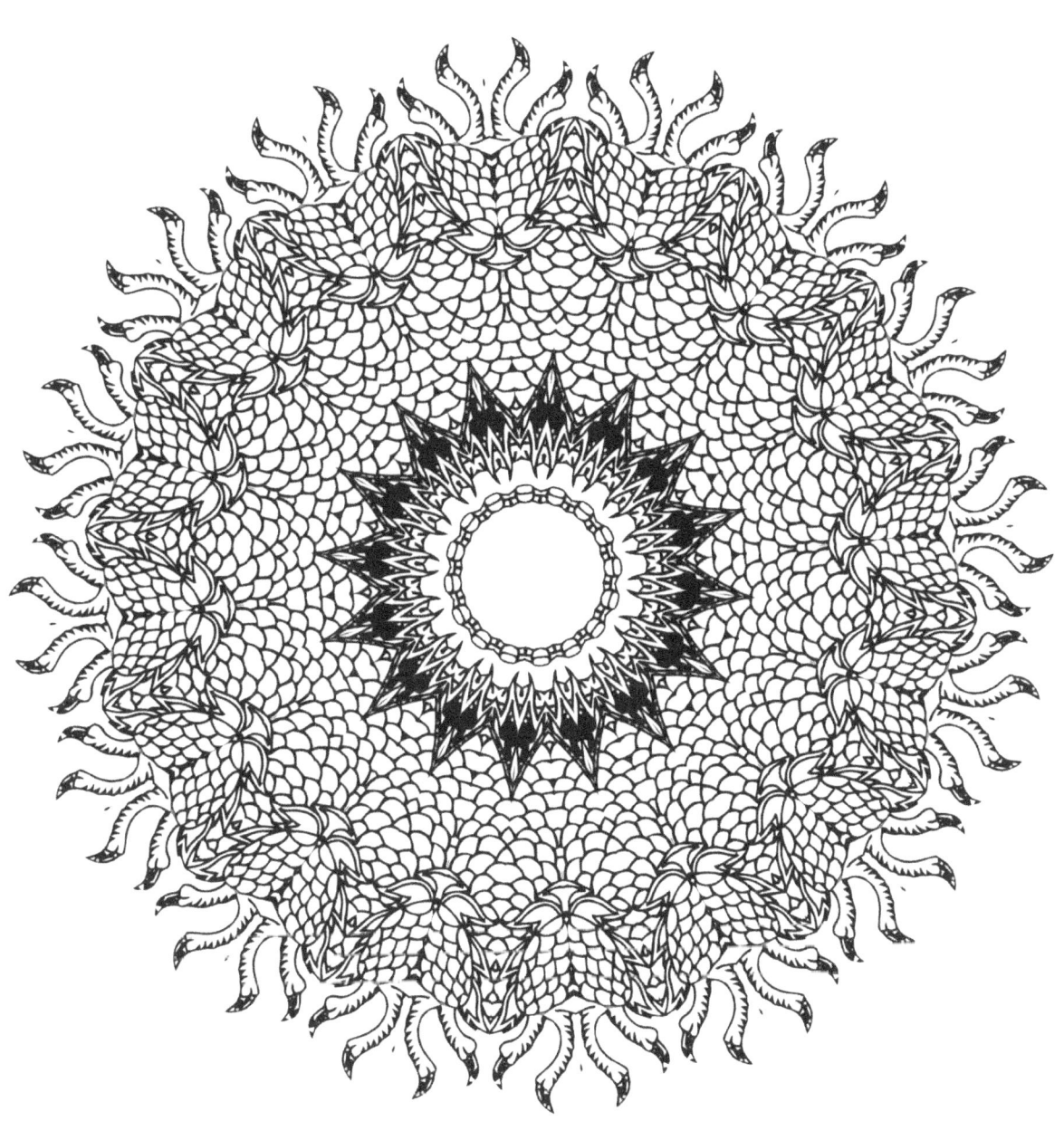

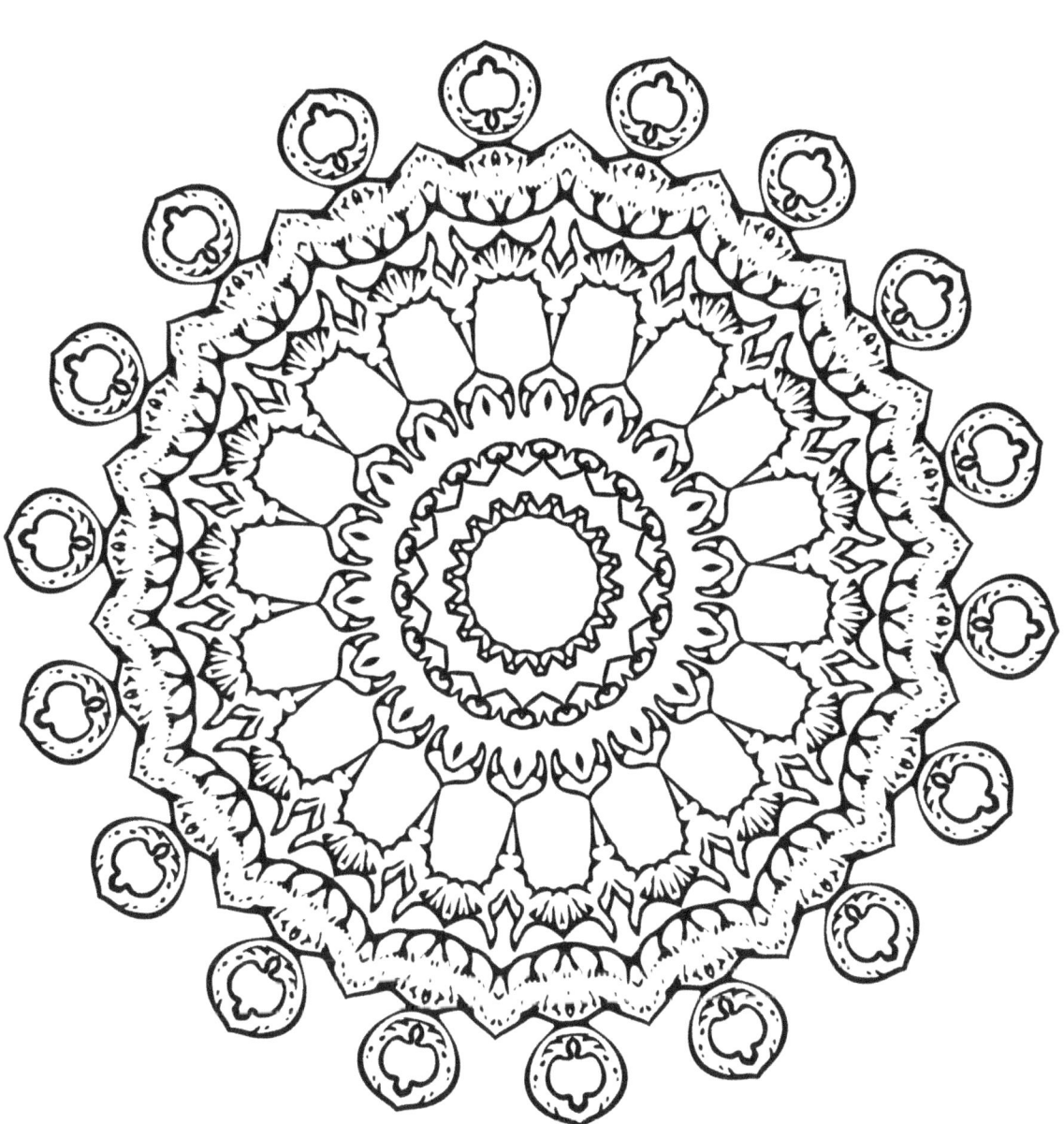

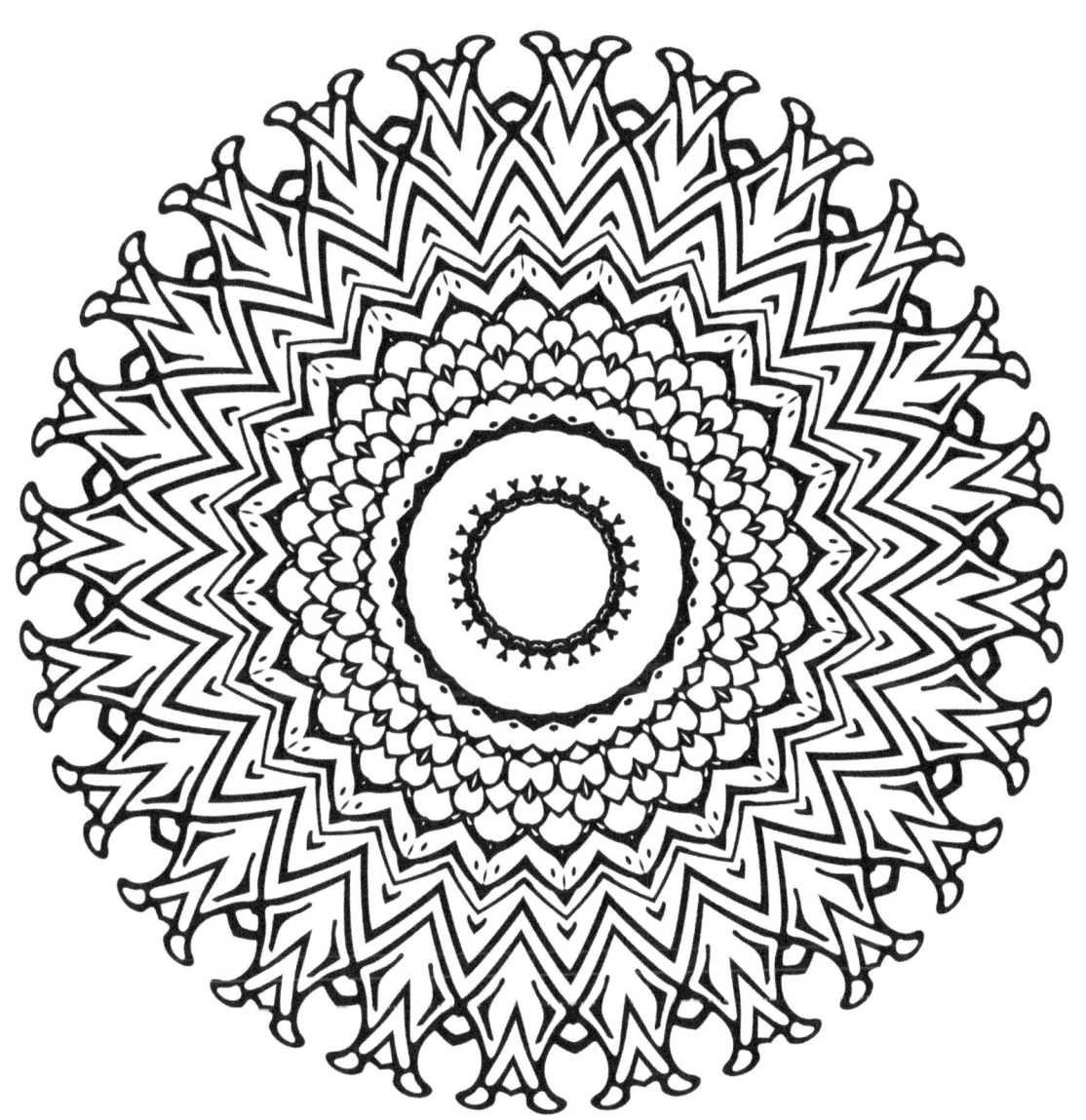

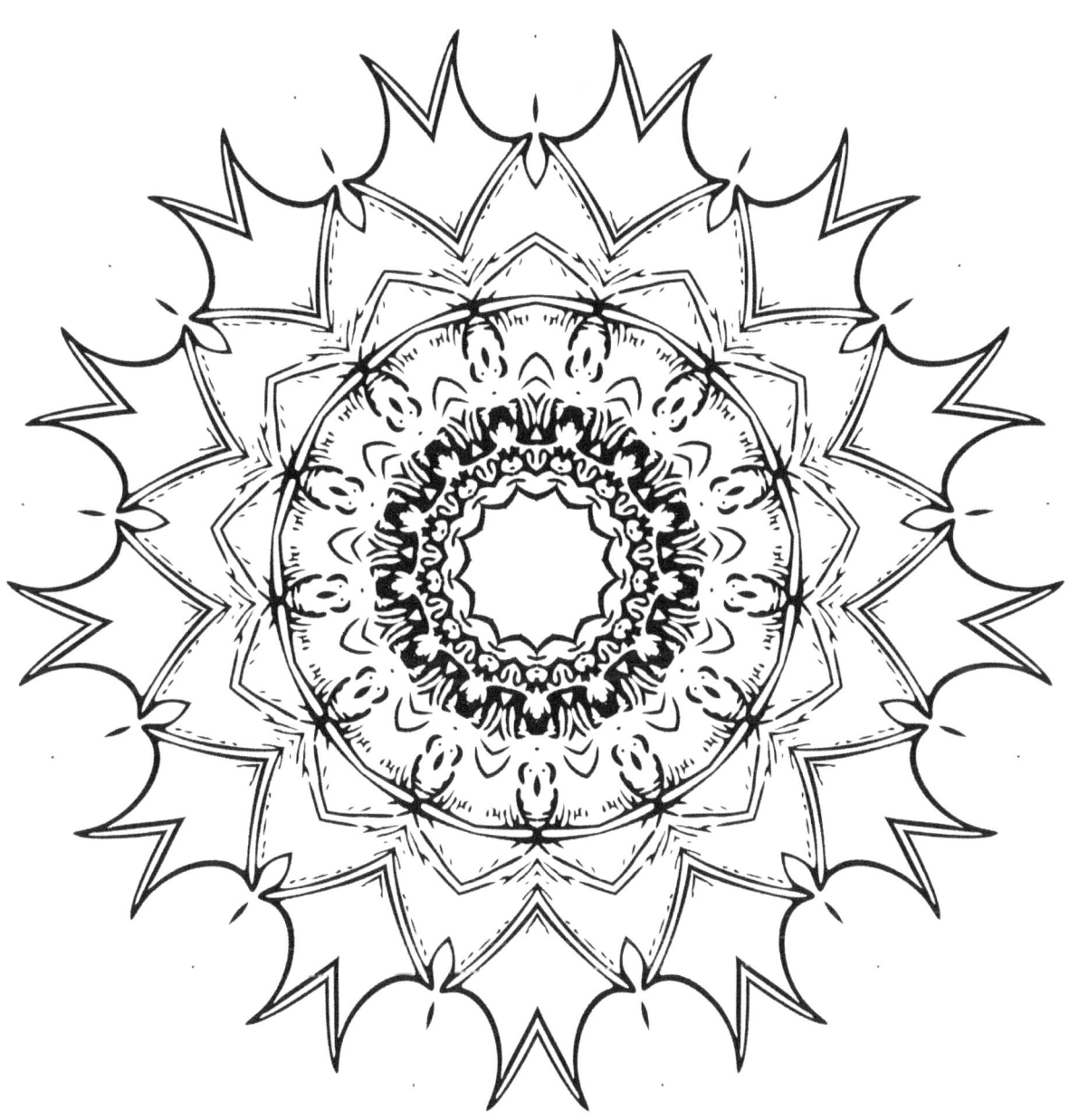

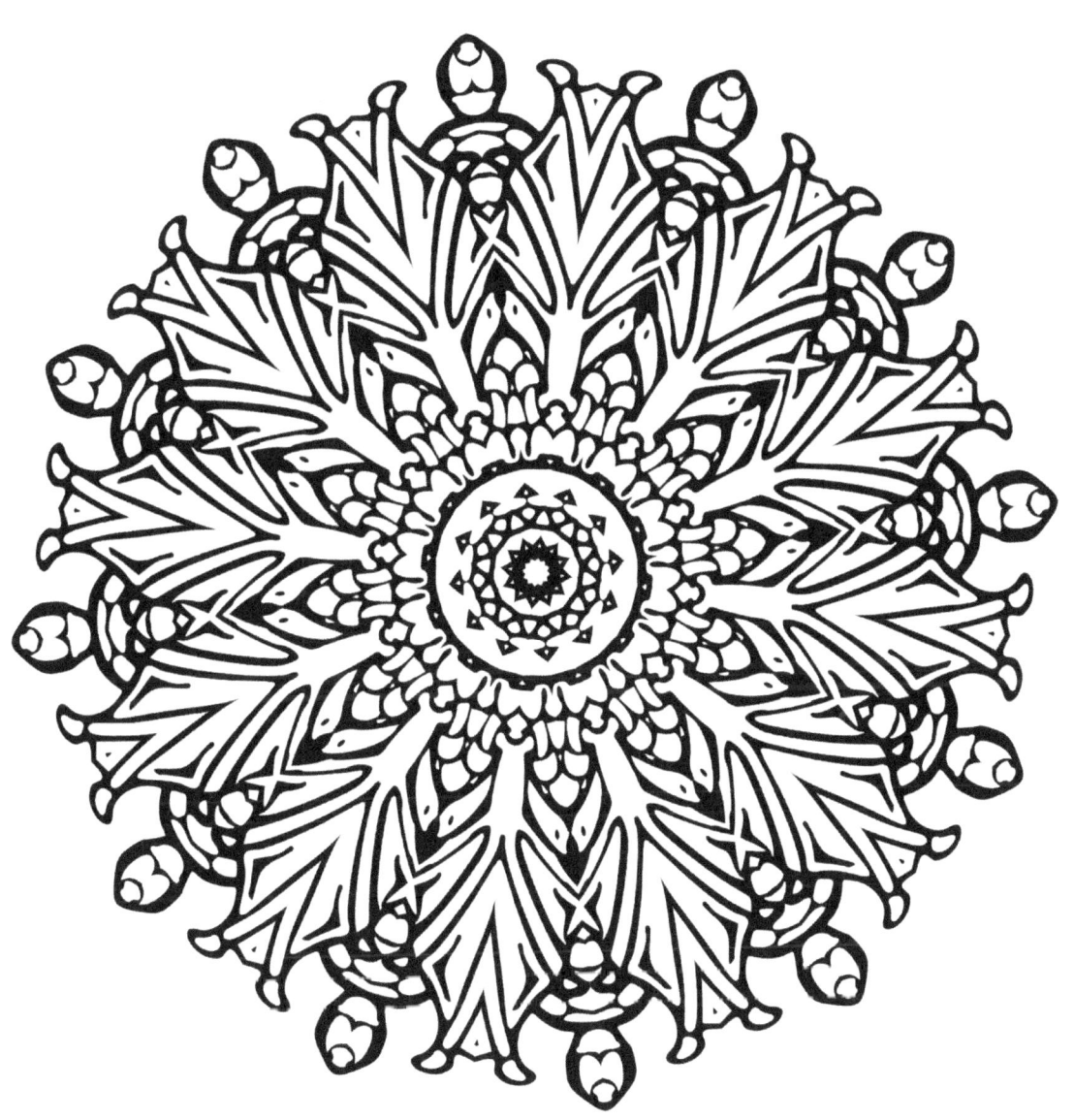

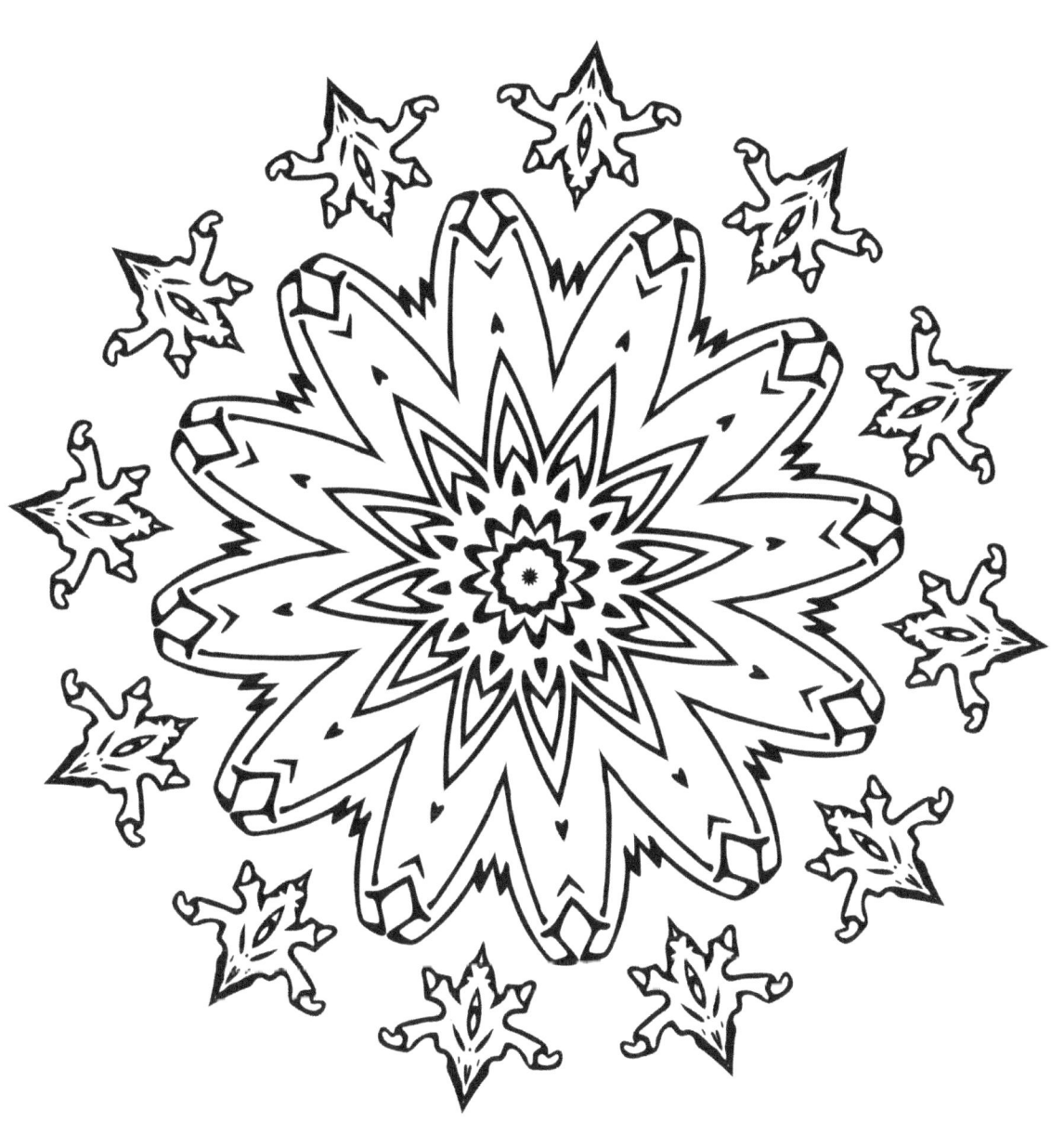

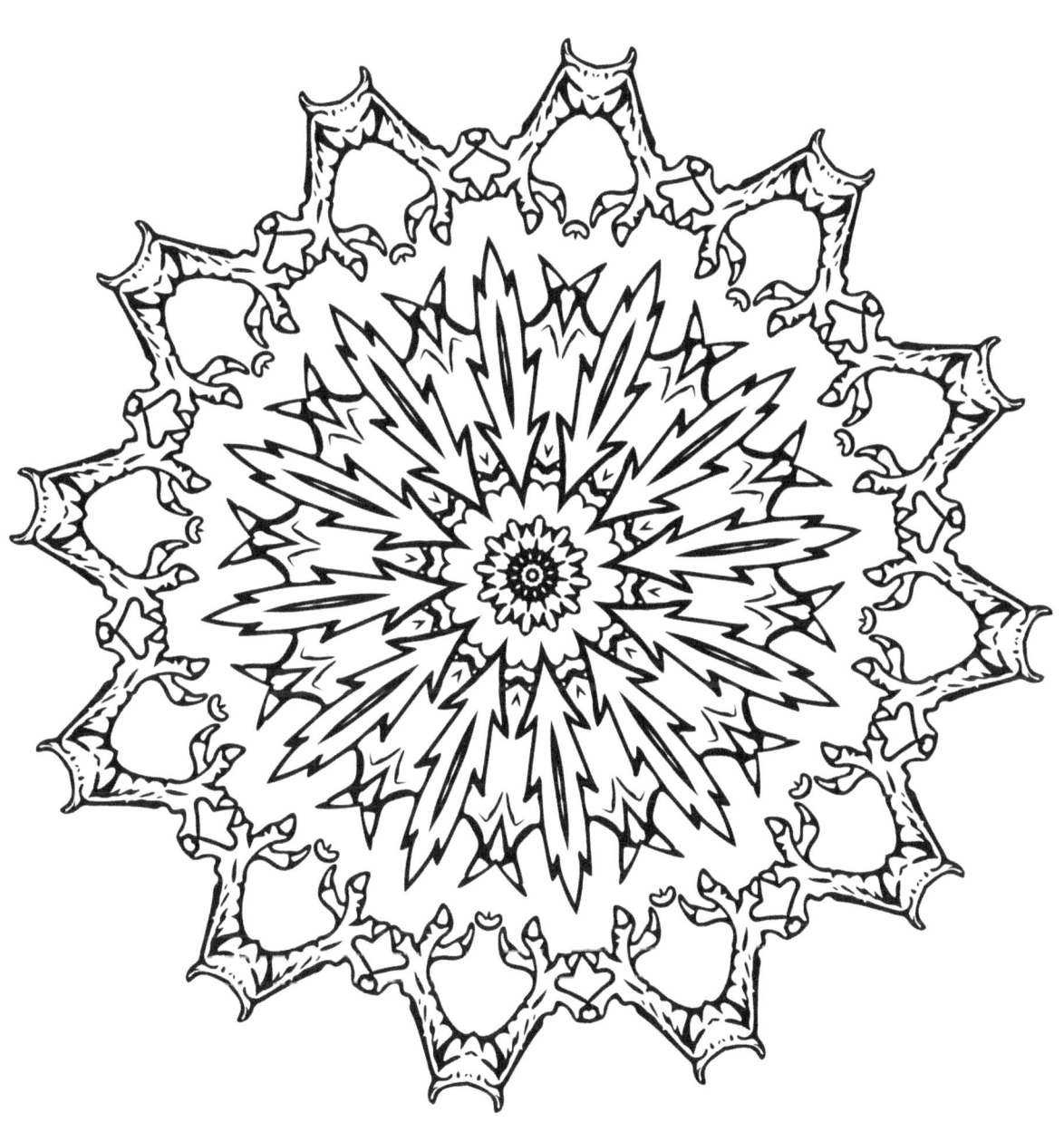

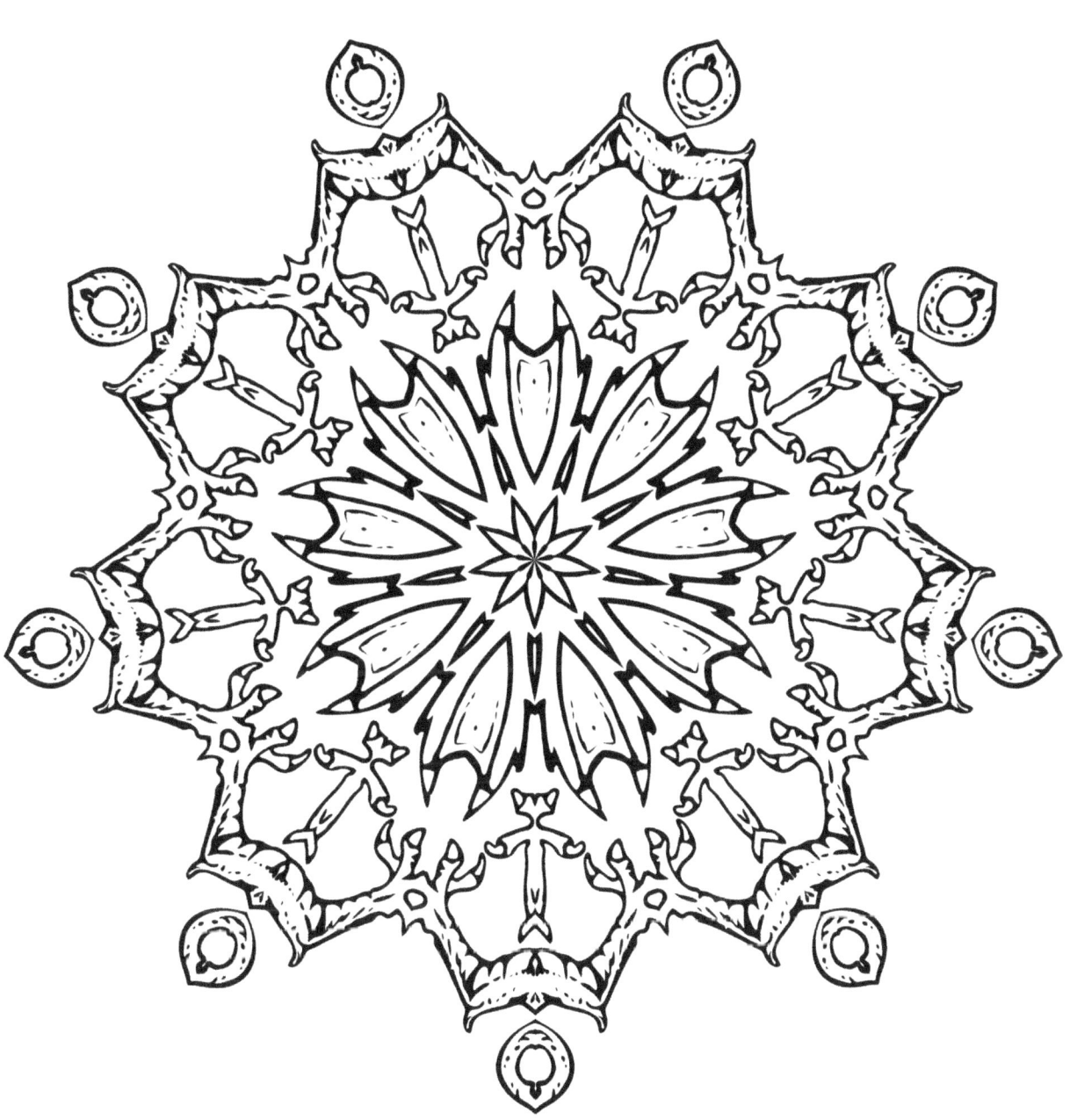

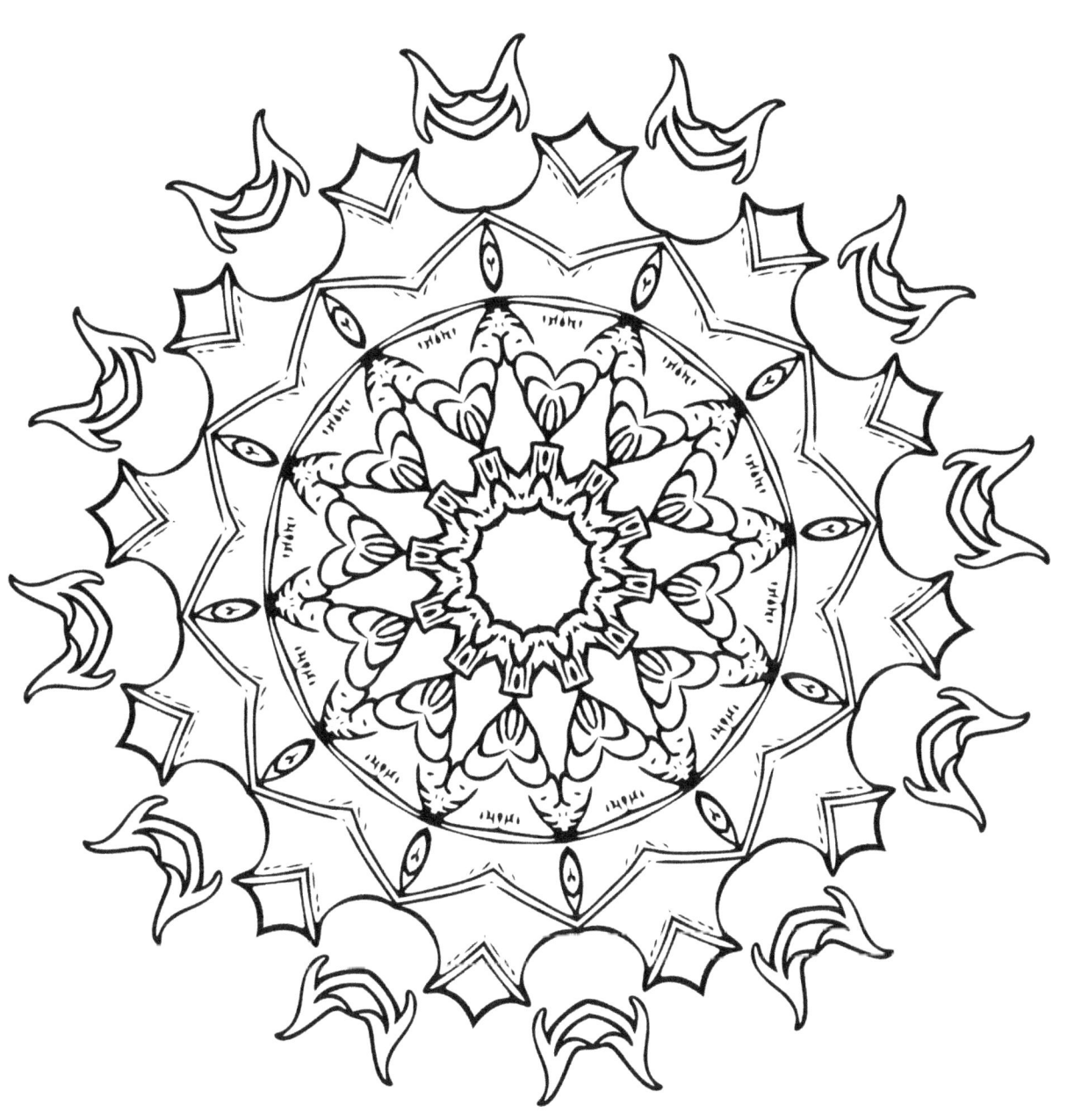

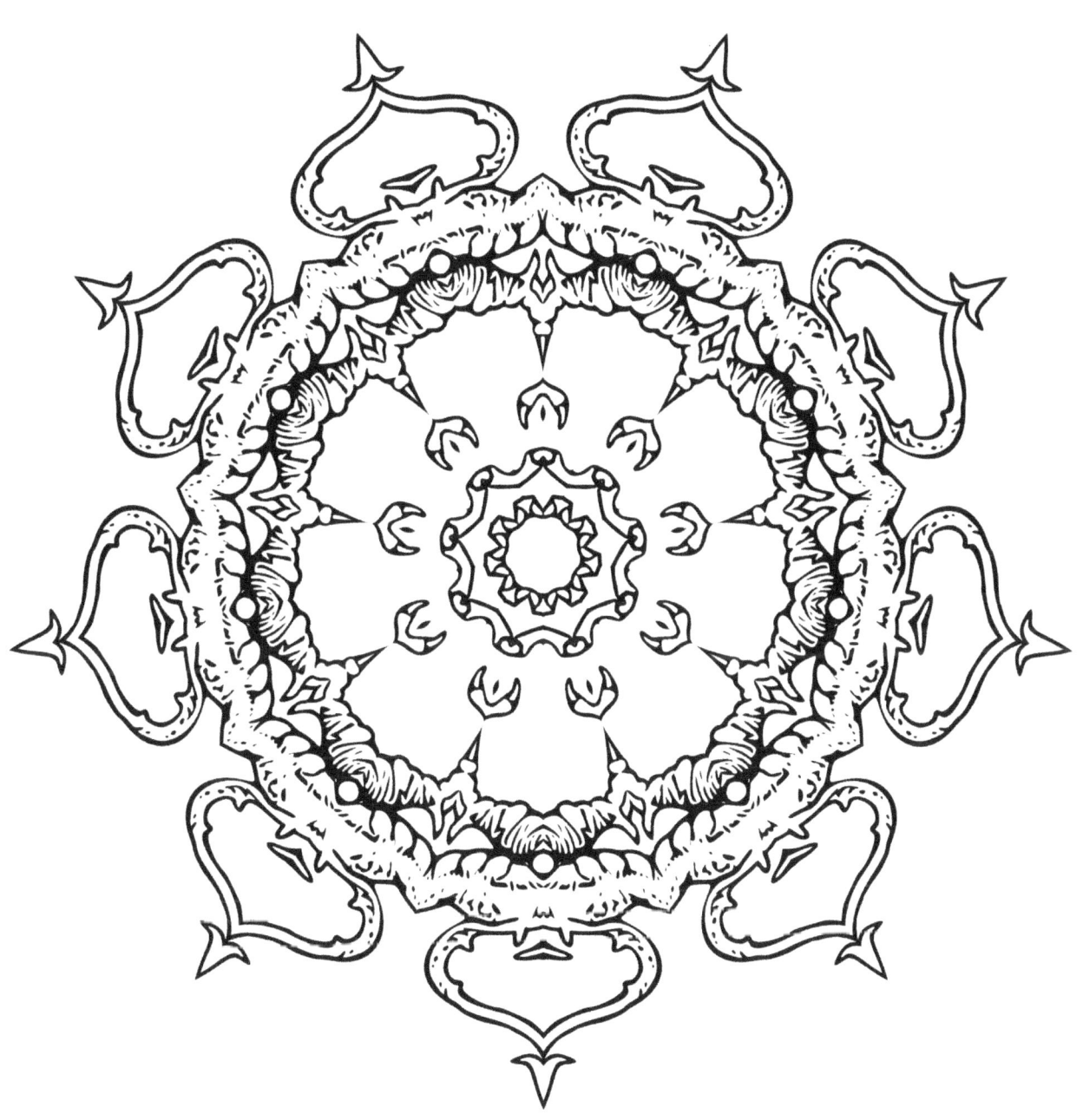

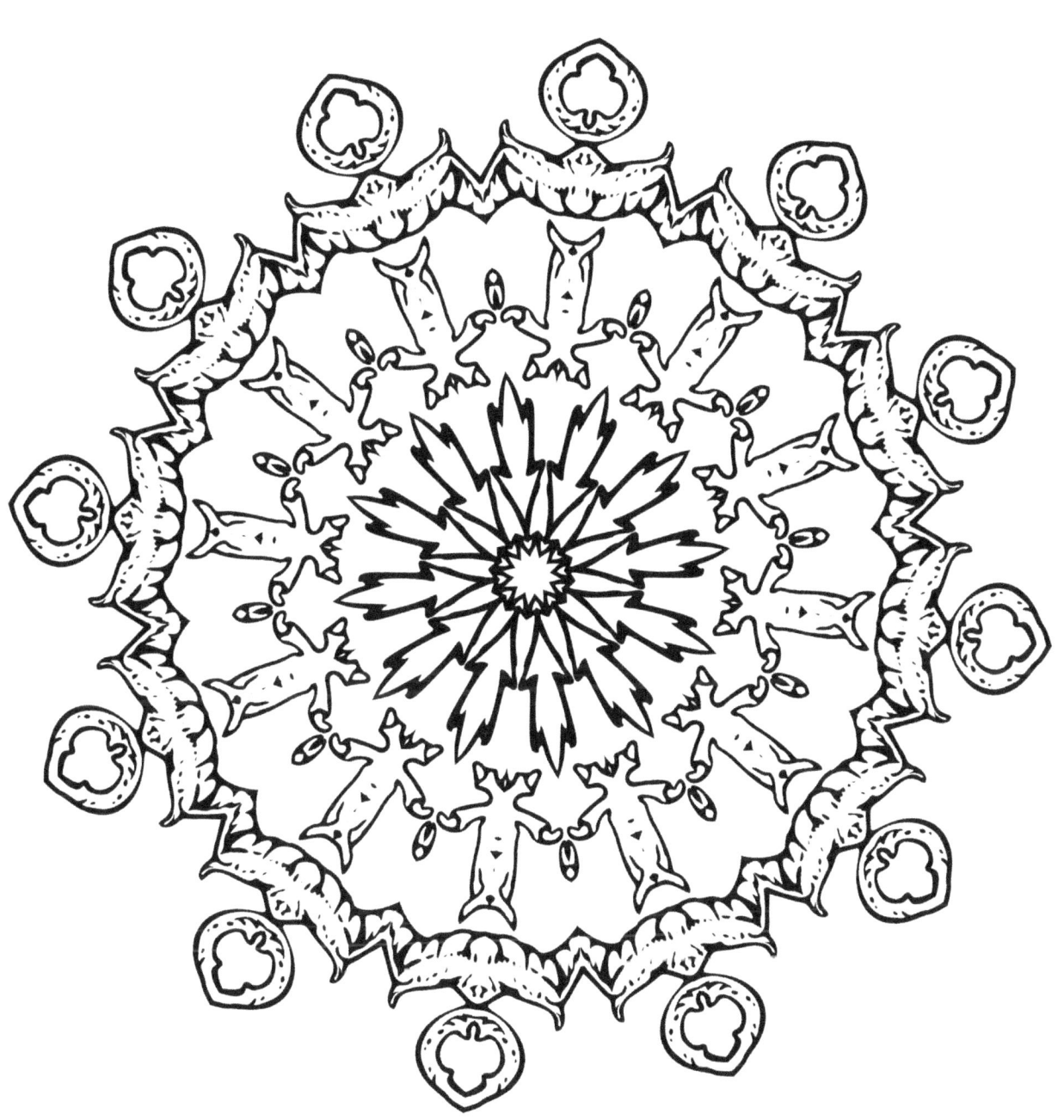

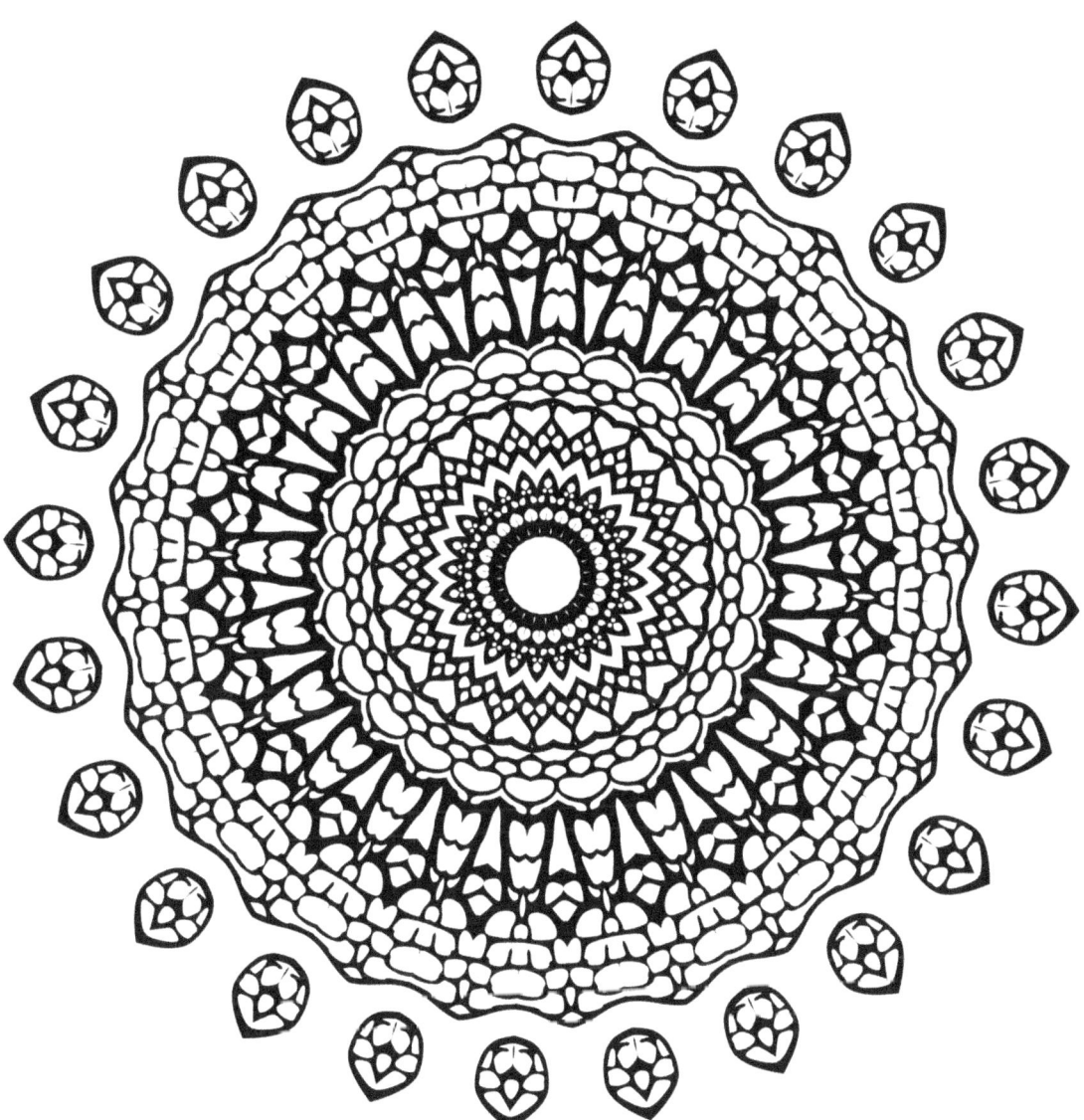

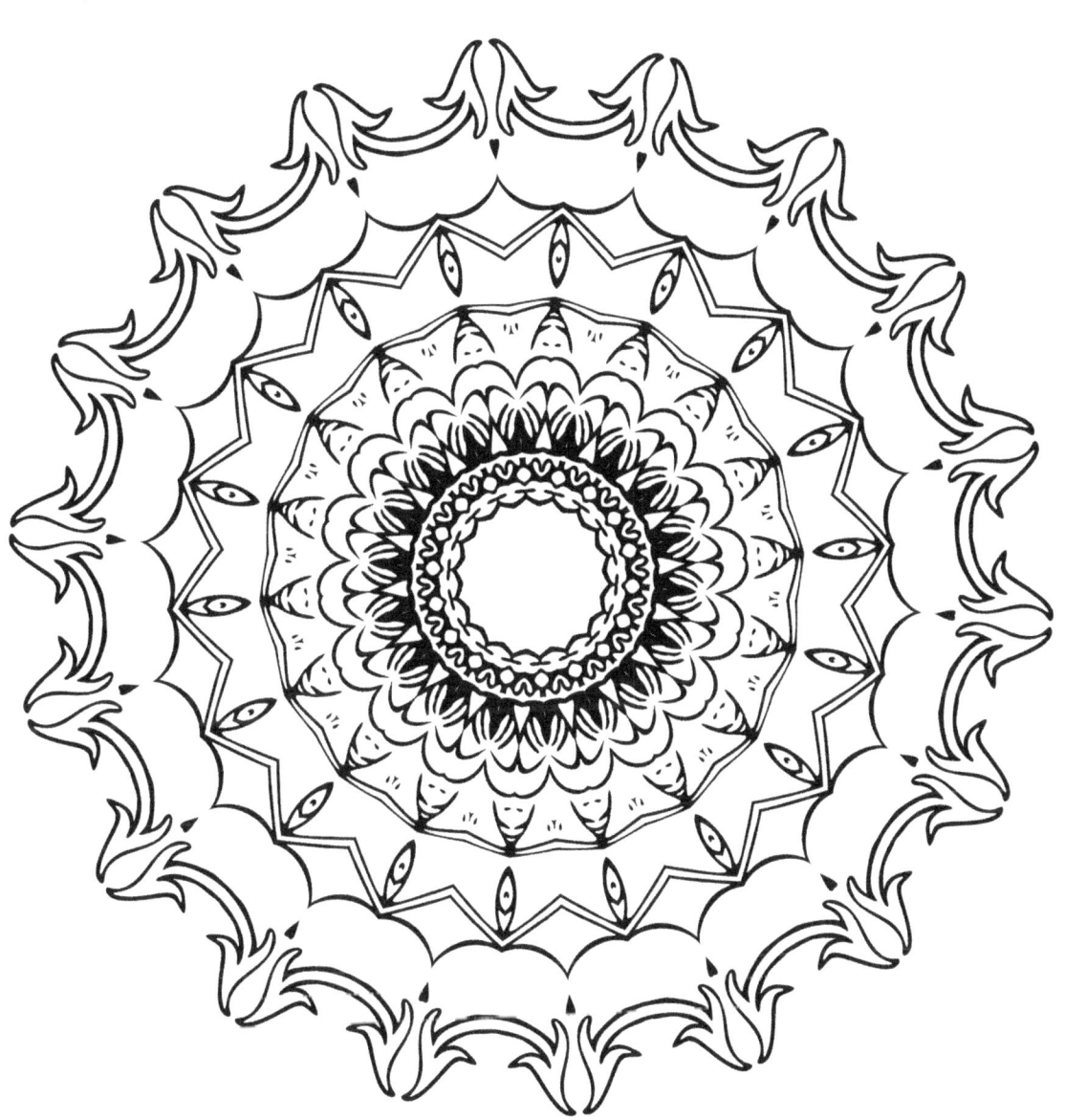

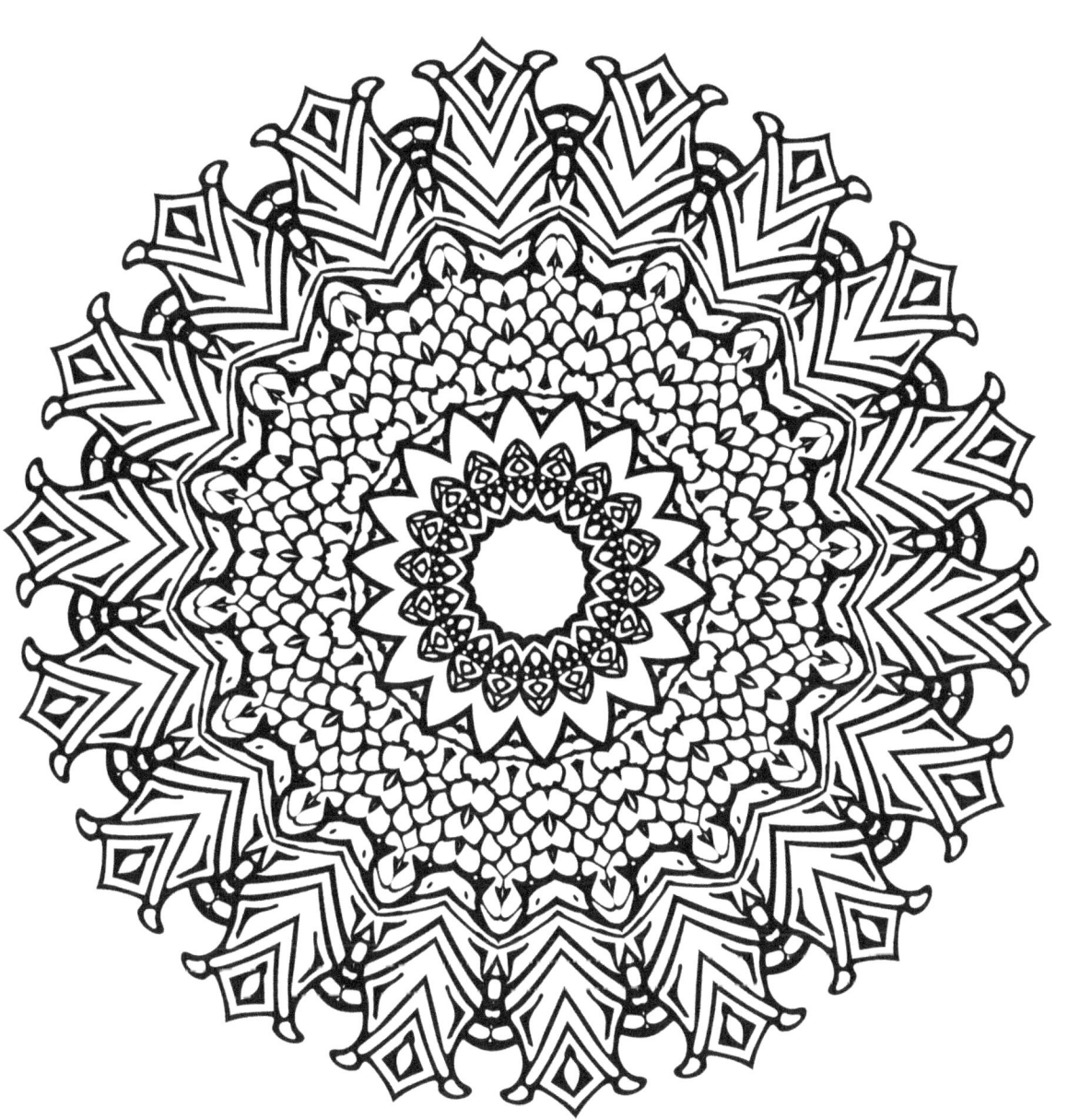

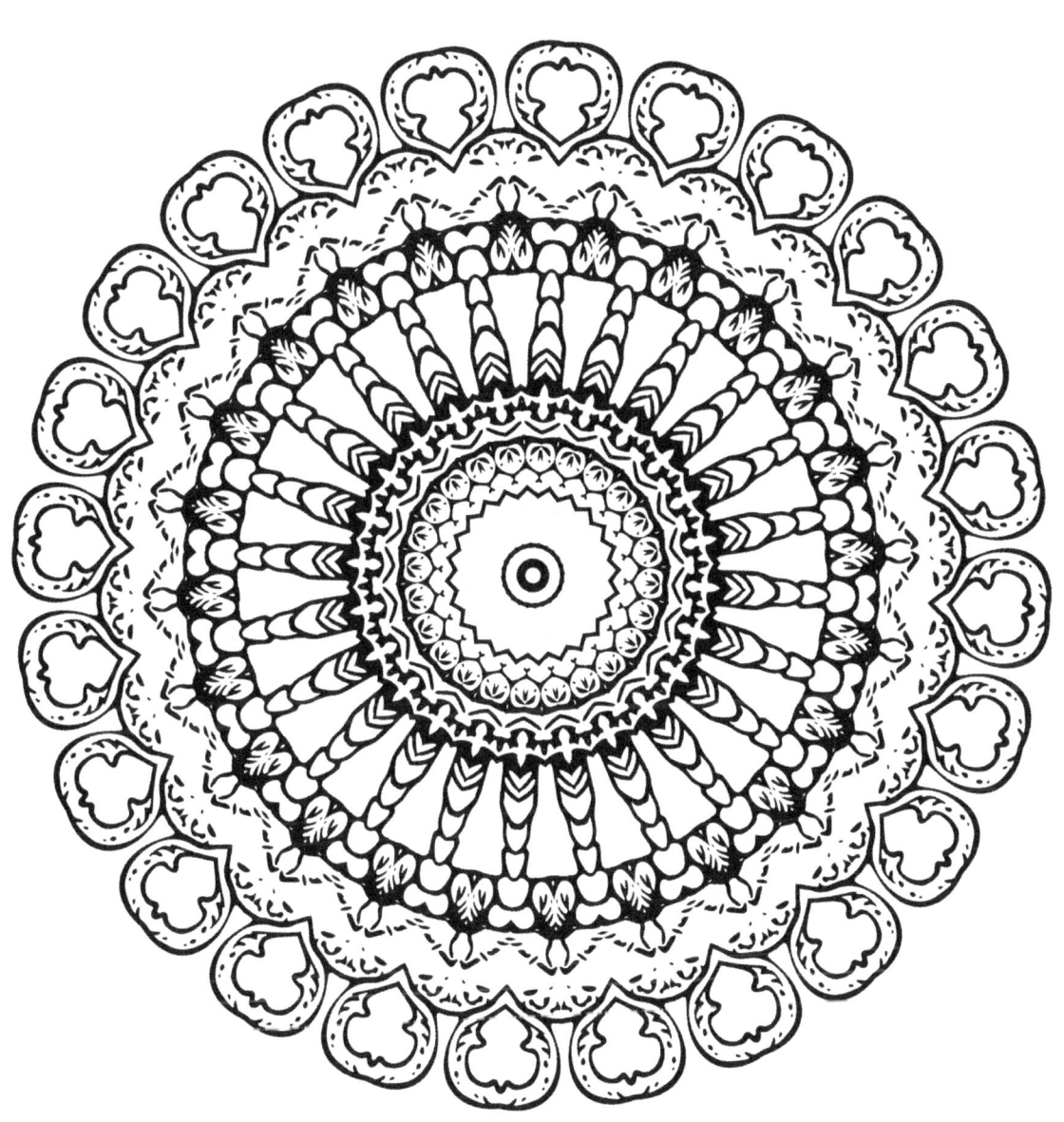

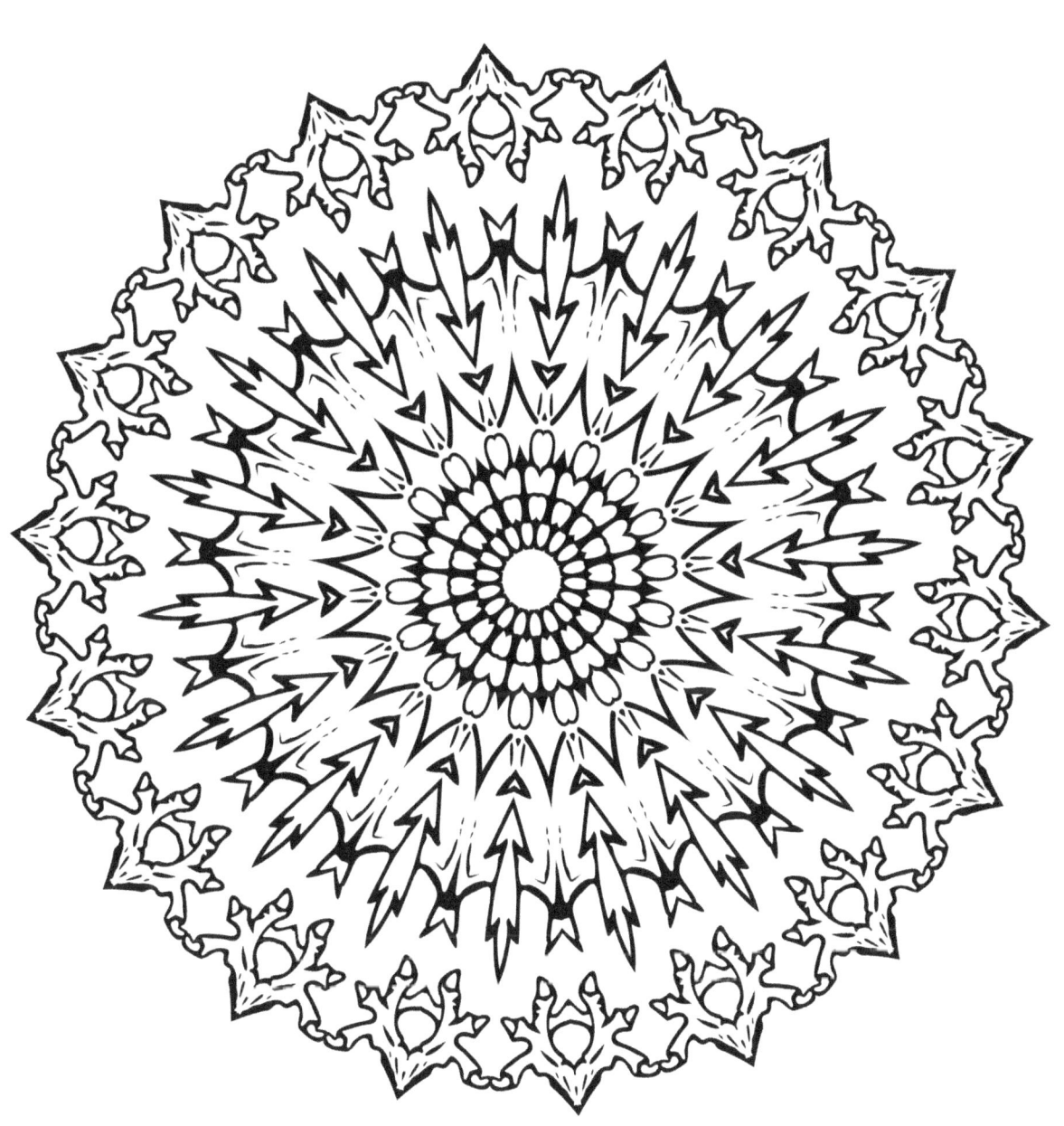

FINAL WORD

Thank you for your purchase!

More coloring books coming soon from Art Therapy Designs.

See our Facebook page for updates and giveaways!

Visit: www.facebook.com/ArtTherapyDesigns

www.ingramcontent.com/pod-product-compliance
Lightning Source LLC
Chambersburg PA
CBHW080713190526
45169CB00006B/2361